Start Now in Watercolour

TOM ROBB

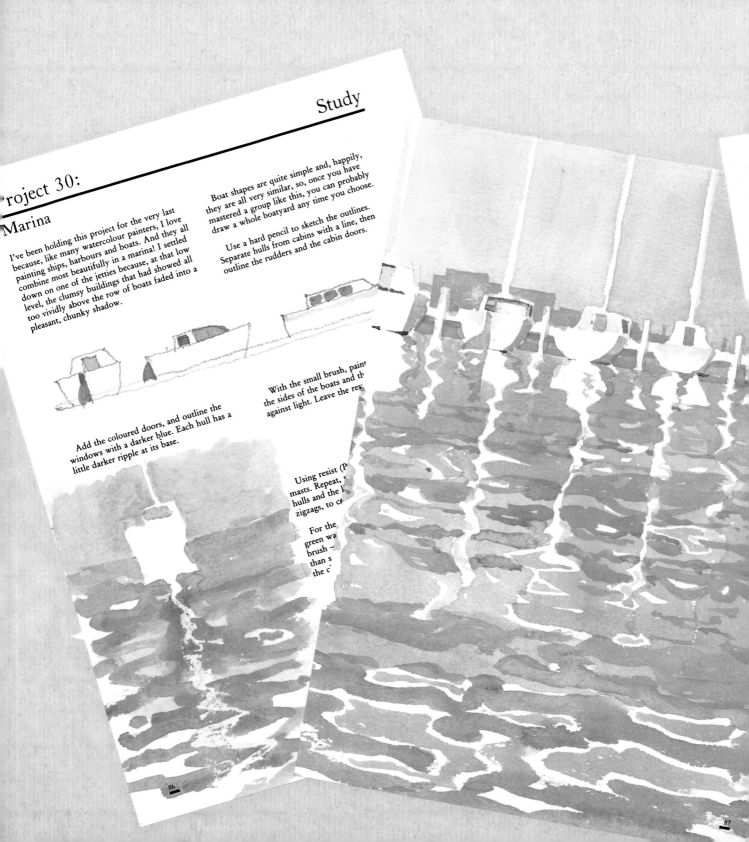

Study

Project 30:

Marina

I've been holding this project for the very last because, like many watercolour painters, I love painting ships, harbours and boats. And they all combine most beautifully in a marina! I settled down on one of the jetties because, at that low level, the clumsy buildings that had showed all too vividly above the row of boats faded into a pleasant, chunky shadow.

Boat shapes are quite simple and, happily, they are all very similar, so, once you have mastered a group like this, you can probably draw a whole boatyard any time you choose.

Use a hard pencil to sketch the outlines. Separate hulls from cabins with a line, then outline the rudders and the cabin doors.

Add the coloured doors, and outline the windows with a darker blue. Each hull has a little darker ripple at its base.

With the small brush, paint the sides of the boats and th against light. Leave the res

Using resist (P masts. Repeat, hulls and the zigzags, to cr

For the green wa brush – than s the c

86

87

Start Now in Watercolour

Sketches

Project 24:

People

ormal drawing classes are good experience for ny artist, but a very surprising number of well-trained draughtsmen cannot sketch. But the rawest of beginners can learn.

There are various tools you can use; measuring will give you proportion and relationship between masses, and it's set out clearly in the Glossary. If you have a camera, photographs are another aid to memory, but will often be blurry. So, to develop an eye for quick observation, sketching people is particularly rewarding. In addition to training your visual memory, live figures are of great value in composition, adding human interest and scale.

Sit down where there are lots of passers-by; a beach, a café, a train station or a shopping centre are all fruitful places. Take with you a medium-sized brush and a little bottle of mixed wash. I suggest wash, instead of a pencil, because it isn't too precise – one brush stroke gives a nice person-shape, and the tip can add feet, a bit of flying hair, an outstretched arm.

Look for a swift impression, not a portrait! Keep everything quick and light. As you practise, you'll get faster and faster. Don't try to re-work mistakes, just start again. Keep all your sketchbooks to use at home.

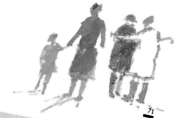

AURUM PRESS

First published 1992 by Aurum Press Ltd,
25 Bedford Avenue, London WC1B 3AT

A catalogue record for this book is available from
the British Library

ISBN 1 85410 206 0

10 9 8 7 6 5 4 3 2
1996 1995 1994

Printed in Belgium by Proost

Contents

INTRODUCTION

One of the anxieties when you first start to paint is finding the courage to make that very first brush stroke. There you are with a piece of blank paper, a rainbow of colour and a world of possibilities all around you.

And that's the trouble, especially for people working on their own. Too many choices – whether of subject, material, equipment or setting – can prevent you from getting started at all.

Start Now in Watercolour is about curing the panic of beginning, by showing how much you can do right from the start. Instead of loading yourself with a great deal of perfectly sound information, which will certainly help – some day! – you can just pick up a brush and get going.

This doesn't mean you are not learning techniques and skills – far from it. Every single project has been carefully designed to give you an insight into a particular aspect of handling the medium with confidence.

But you learn by doing, rather than by reading about it, with each element in the pictures taking you that much further into the craft, acting as a kind of building block which you can use to construct your own style and your own approach to the subjects.

Once you have realized how easy it is to make exciting pictures you are proud to hang up, we hope you'll begin to see how satisfying painting can be.

Get started, and good painting!

Tom Robb
Phoebe Phillips (Editor)

PART ONE: STARTING NOW!

We're going to begin with classic simplicity: three projects to whet the appetite and set your creative imagination going.

Turn your mind away from a complicated subject, with a dozen shapes and sizes, and hidden lighting. Forget about the fifty-odd colours that the best paint companies sell, or whether your brush should be a number ten bristle flat or a number two sable round. For the moment, stop worrying about the laws of formal perspective or learning to draw.

Find a few, very simple props: a glass and a handful of flowers, a bowl, a plate and a few pieces of fruit. Plan a visit to the park or a garden where you can see a clump of trees.

Buy two brushes, one flat and thick, and a medium round one for detail; a box of watercolour paints and a pad of good-quality watercolour paper are all you are going to need.

Start each project by practising the different elements on a separate sheet. Do use the best paper you can afford, even for practising, because the effect is so much better that it will encourage you to keep going!

When you are comfortable with handling the brush, then start on a fresh sheet, using the elements in the way that pleases you best. When you've finished the three projects, pin them up as proof that you have really started – as of now!

Flowers

Starting with a wide, flat brush is much easier than trying to achieve the same broad effect with a smaller one. Keep the small brush for thinner lines and details.

Make sure your wrist is relaxed, and paint the vase shape in a comfortable curved flick. Hold the brush so that you use the full width of the bristles. Work on a flat surface so that the paint doesn't run. Use plenty of water and colour. Don't worry about straight edges – it's the essence of a container you want, not a detailed portrait. You can try out different shapes, but keep it simple. The curve of the brush stroke is all you need to suggest roundness.

The flowers are triangular splodges, made with the edge of the thick brush. Experiment with different amounts of colour and various mixes. Remember that in a natural arrangement the flowers would fall loosely, so don't make the shapes all the same.

Use the small brush, holding it lightly and with the handle pointing straight up, poised above the paper. Pick up less water and not too much colour. Lightly flick the brush up and down to make the stems, with shorter flicks sideways and upwards for the leaves. Don't try and copy each leaf; just put in a few here and there.

When you start the project on a fresh sheet of paper, be bold and fill the page. It's best to work logically – paint the vase first, scatter the flowers above, and then add stems leading down to the container. Centre the stems under each flower to lead them back to the vase.

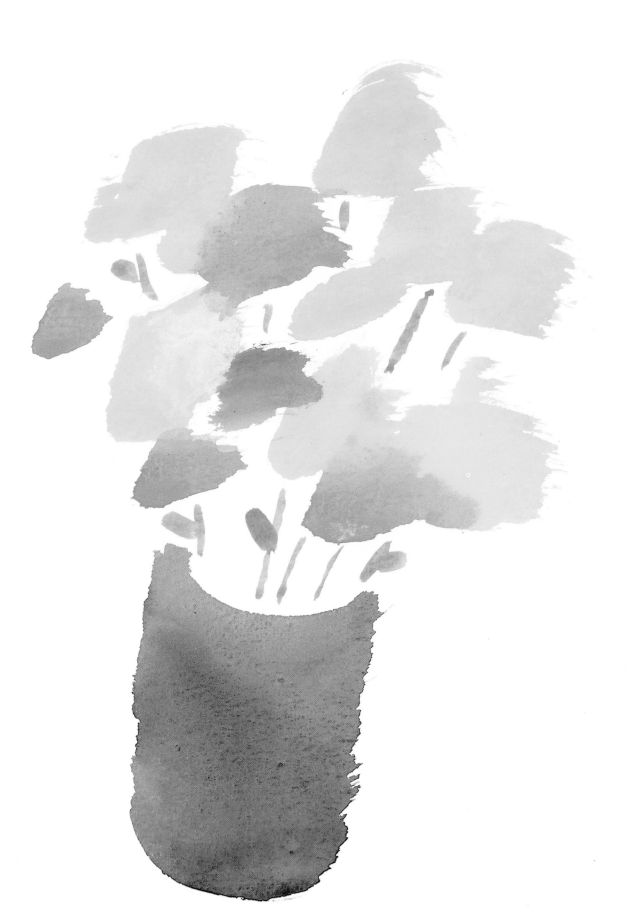

Clump of Trees

Trees seem such complicated subjects, with branching systems, thousands of leaves, different barks and so on. But using the broad impressionistic approach is quick and effective right away! Start with yellow and a little blue for a spring green. More blue will give the darker, softer green of mid-summer; add a little red for the brown of autumn foliage.

Use plenty of water and your large brush. Splosh the paint in short strokes, from left to right, then lift and work from left to right again, just below, to make the broad tree head. Try round shapes, like old oak trees, and taller and thinner shapes, like conifers. Learn to look at shapes, not at the details. As you learn to work more quickly, you can zigzag across instead of lifting the brush at the end of each stroke.

Make a few broad horizontal strokes. Paint vertical strokes on top, and immediately dry your brush with a bit of cloth or the fingers of your hand, and then go over the vertical lines again. This will pick up some of the water and paint, leaving you with lighter vertical lines standing out against the background.

Put the elements together by painting the heads of the trees quickly, then washing in the ground level below in broader strokes. Connect the two by drawing paint down from the head, and immediately pull off some of the water with a dry brush to let the trunk stand out against the background. If you find you're too slow and the paint has dried, just fill your brush with clean water and go over your strokes. Let the water soak in for a moment, no more, and then you'll find you can pick up the colour easily with a dry brush.

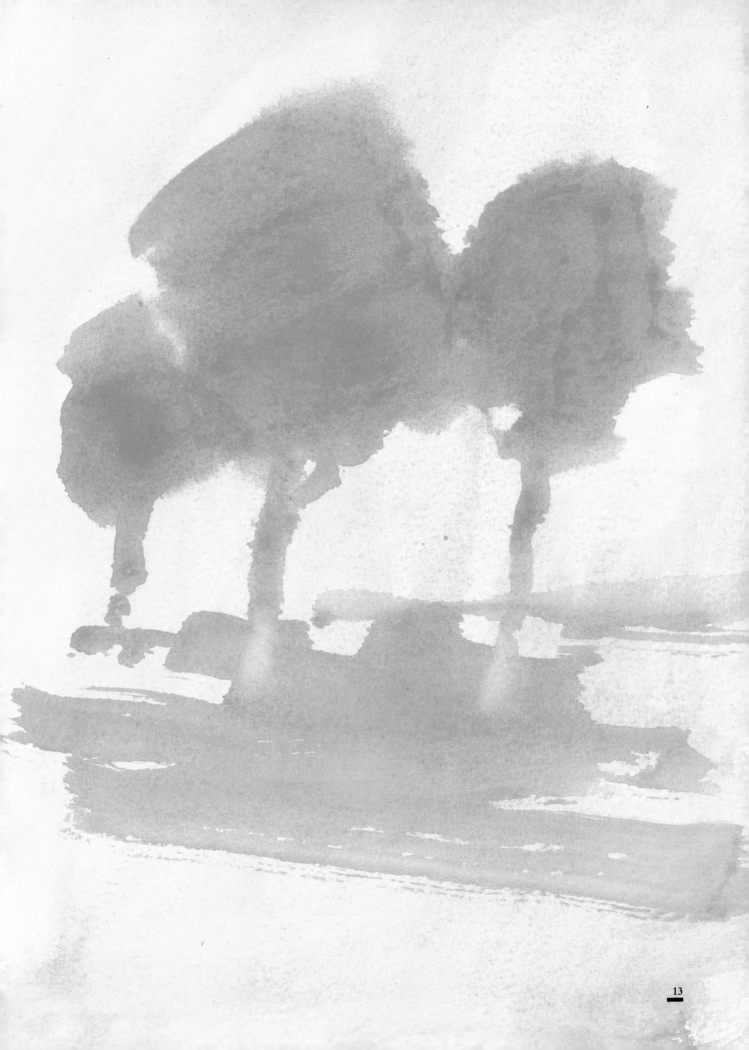

Project 3:

Still Life

Looking at the Dutch masters is quite enough to discourage anyone from trying to paint a still life. But modern painters can be a comfort and a revelation, showing how much can be achieved with very little. The previous two projects have introduced handling the brushes in blocks of colour. Here we use line instead, drawing in watercolour.

Using the smaller brush and a simple mix of red and blue, make broad outlines of the plates, the stand, the table edge. Practise taking up enough water to give you a whole outline, but not so much that the paint runs.

Make sure your strokes are long enough to paint a complete oval, a circle, or the table's outline. You can't fudge with watercolour, and a break will show.

Practise working with the full brush to give you a broader line, and using the tip only to give a thinner line. The use of two kinds of line in painting the tall fruit bowl helps to achieve a sense of three dimensions, with the broader line at the front, and the narrower further away.

A very few touches of lighter colour just give a hint of shadow. Add lots of water to reduce the colour, but then brush off any excess moisture before you paint. Keeping the outline distinct from the inside colouring is very important to the final effect. Make circles of the purple, then wait until they are absolutely dry before adding the interior colours of the fruit.

PART TWO: WASH AND WHITE

Washes are the basic tool of all watercolour painting, exploiting the transparency of the colour and the fluid stain of the paint.

The most important technique is the freedom of movement that will take your wash across the page in one comfortable sweep. The most common fault of beginners is not using enough water, so that the wash comes to a dragging halt.

Another vital lesson is learning to control accidents. No one can determine exactly how the paint will run. Changing your picture to include some lucky effect is a continual challenge.

The finish of the paper also determines how the paint dries. Some papers have an impressed pattern in order to hold water – this will give your wash a shadowy design that you may not like, so experiment with individual sheets before you buy in quantity. Handmade paper has irregular patterns, creating a fluid and natural effect, but it is expensive and best kept for ambitious projects.

Because watercolour is inherently transparent, there is no white paint you can use except gouache, which is opaque. So the artist uses a variety of techniques to create the same effect; the simplest is painting *around* the spaces which are intended to be white and letting the paper work for you.

The related techniques of wiping out and sponging off are both similar ways of using the underlying white or colour of the paper as a positive asset.

Landscape

Using the wide brush, plenty of water and not too much paint, brush freely across a sheet of paper. Make sure you cover the paper from side to side, then work quickly downwards. Try and keep the colour even, then experiment by pressing on the brush a little more heavily along one side to achieve a graduated wash. Sometimes, depending on the temperature of the room or the moisture in the air, the paint will take quite a while to dry. Tilt the paper up a little by resting the top on a book, and the colour will run down and dry with a darker line along the edge.

Once you have a feel for the sweeping movement, work in the different colours related to landscape – blue for the sky, soft blue or green for distant hills, added yellow ochre for fields of wheat, and soft green for the foreground. Precision has no place in this; get your wrist and elbow working in comfortable curves, swirling up a little for clumps of trees, with broader strokes for the hills.

Leaving a few white spaces between the colours adds light and air to the picture, but try painting with linked washes and see if you prefer that.

The most important point to remember is to have enough paint and water on the brush when you start – beginners almost always use too little of both. Much better to slosh paint over the paper and have it crumple than try to correct a tight, scratchy line.

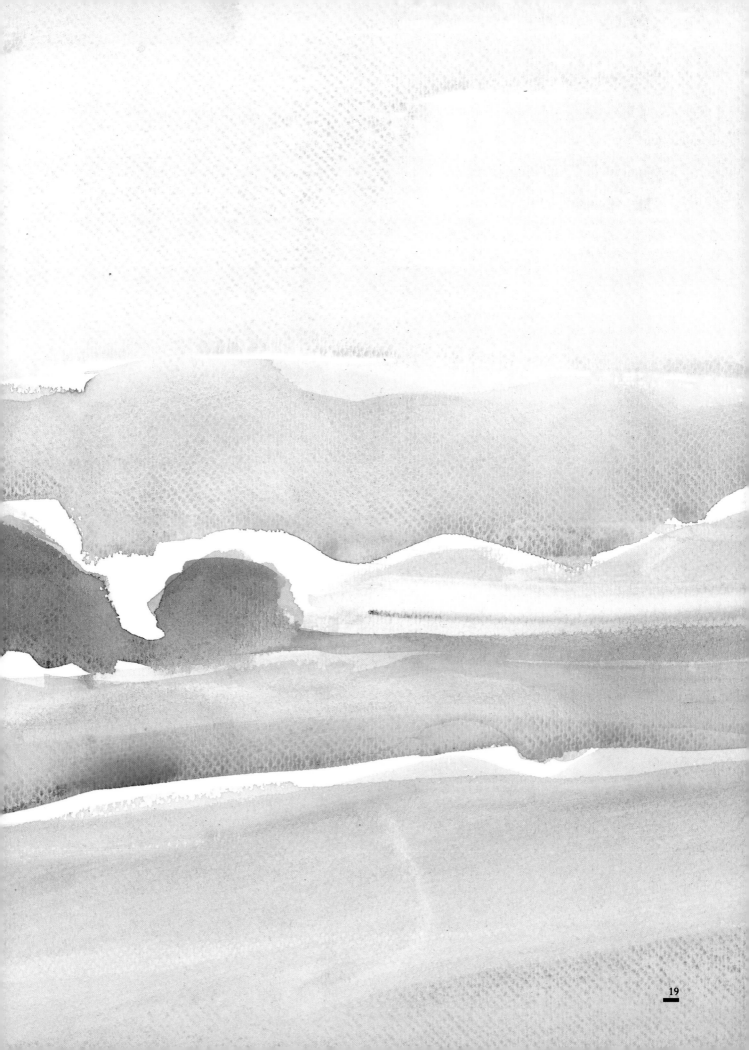

Marmalade Cat

Another technique for the painter who wants to use white or a paler tone is to wipe out a colour or a wash. The only extra equipment you need is a small sponge or a piece of cotton rag, and a cotton-tip stick.

Painting circles and ovals can be easier than it seems. As this is not a geometric figure, then a freehand movement of the wrist should give a comfortably rounded shape, but lightly pencil it in first if you feel you need to. You'll need to mix the colour with yellow and a little red. It's quite a large space, so use plenty of paint and water.

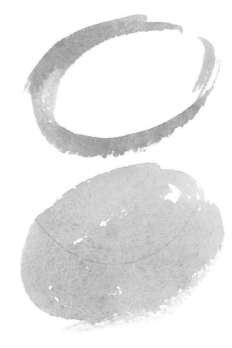

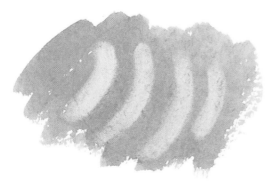

Wait until the paint is dry, although not too dry! This is a skill you'll learn easily. Too wet and the edges where you wipe away the paint will creep back and be fuzzy; too dry and you may need to rub hard and damage the paper. Any damp absorbent rag will do, or the damp tip of a cotton stick. Gently stroke in semi-circles and the paint lifts off. For larger areas, like the cat's face, a piece of rag is better than the stick. You can control the amount of wipe-out simply by going over the same place and lifting more and more of the paint. With good paper and fresh paint, you could even take it right back to white.

Put the elements together, wiping out a large area for the cat's face, then just stroking in the eyes and a few whiskers. Remember to leave a bit of darker colour in the ears.

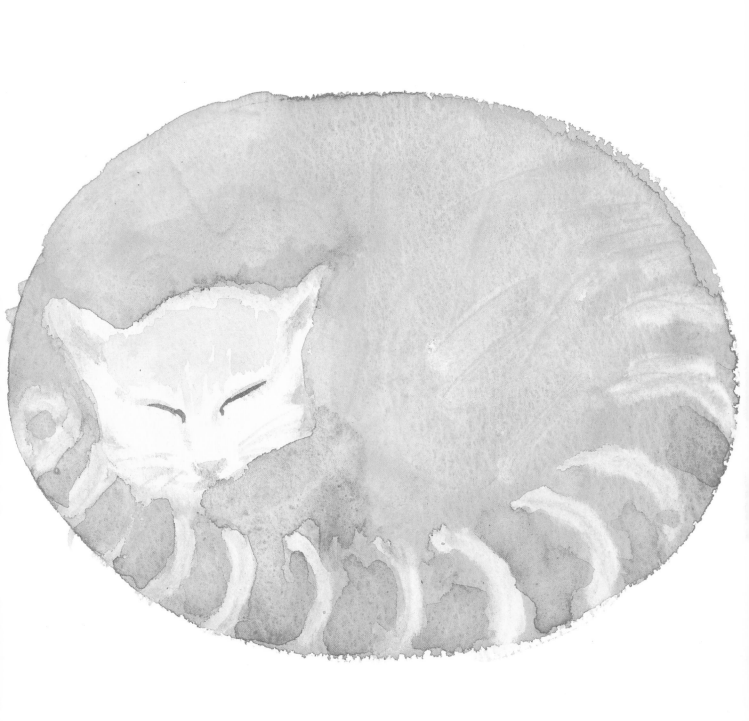

Project 6:

Beach Umbrellas

Using white paper to 'paint' with is one of the joys of watercolour. The freshness of white gives a feeling of sea air. It doesn't really matter what colours you use – just make sure they are clean and bright.

It takes just a little control of the brush to keep lines separate. Start by making a short stroke, about an inch or two long. Don't worry about it being too straight or too even. Paint another line underneath, a little longer at each end, and then another even longer, and so on. Once the surrounding colour is painted, the lines will turn into a striped umbrella. If you make five or six strokes, increasing gradually, you will have a shallow arc. If you make just three broad strokes you'll have a deeper arc.

Wash an area with a light ochre, using plenty of water. Normally, if you are painting with the pad slightly tilted, the water will drip very gently towards the bottom, creating a darker colour. If you want a shadow on the top, as I have used on the sand, then simply turn your picture upside-down and the water will run gently the other way. Unless the angle is very steep, water will collect along the line of your wash without dribbling down any further.

For two adjacent washes where you want the darker edge only on one, let one wash (here it's the blue) dry flat before you add the other and tilt the paper.

When you put the elements together, leave a white space between the blue and the ochre, and around the umbrella sticks. Separation with white emphasizes the shapes and colours without darkening the picture tones.

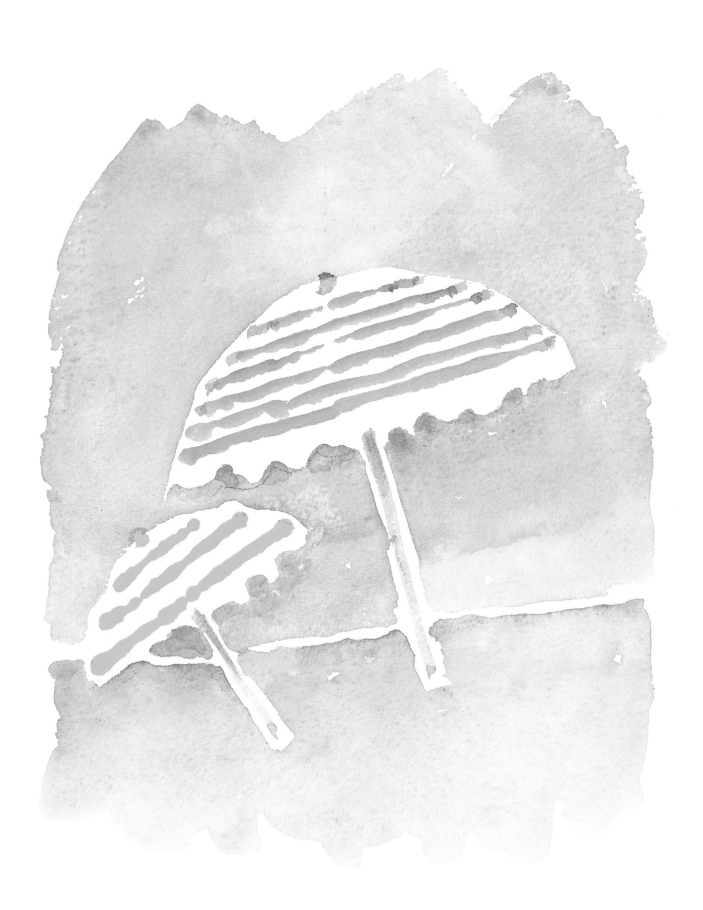

PART THREE:
BRUSH STROKES

It may seem a contradiction, but once you've learned to be free and open with your wash, the next element to learn is firm control of the brush.

Brush strokes are the structure of watercolour. When you work in oil, the paint itself has dimension. It creates a physical presence on the canvas which gives substance to the work.

Watercolour – and particularly the transparent watercolour wash – is very different. The water evaporates as you work, leaving only a stain of colour.

Because of this delicate quality, you will need control to make sharp and precise marks. These anchor the broad, blurry washes to the paper, giving form and substance to the painting.

Comfort in handling a brush is very important. Try to make all kinds of marks with your two basic brushes – little dots, cross-hatching, splodges and splashes, delicate lines – it's all good training.

There are many brushes manufactured for special uses, from the miniaturist's tiny thread (as fine as a scalpel) right up to the big, fat washing brush that looks appropriate for walls – but these are luxuries you can keep as rewards for your improving skills.

Wheat Field

Watercolour is very sensitive to the skill with
which you handle both paint – the medium –
and the tool you use, a brush. Keeping light
brush strokes smooth and even is quite
important, and it's not difficult to achieve if
you keep your movements relaxed but firmly in
control. Creating a picture entirely from thin
lines is quite a challenge, but you will enjoy it.

Using the point of the thin brush, pick up
enough paint to make two or three short marks.
Unlike a wash, accidents are not that desirable –
you want to be able to put your lines exactly
where you have decided they should go, so
keep the water to a minimum. Add a few extra
short strokes on top for additional colour.

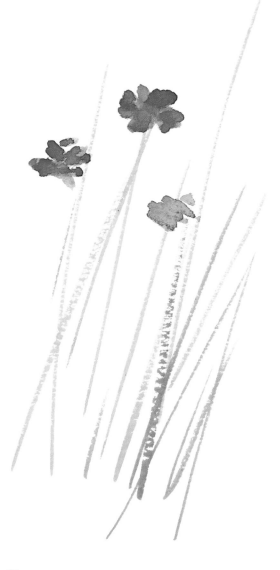

Work quickly at first. Trying to slow down
may increase the tension in your wrist and
make the lines uneven.

When you are confident, paint in longer lines
which run parallel with the length of the paper.
Practise painting the full length in one stroke,
although you might have to renew the paint for
every stalk.

A few green stalks create a muted contrast.
You might try a tiny butterfly or a ladybird,
just drops of red and black, for the same
reason. A red poppy or a subtle brown and
blue dragonfly could be used equally
effectively.

Bookcase

Once you can control your brush marks you will be able to paint with clarity and precision, and without blurring the colours. There are three techniques that you can use for working with thick blocks of colour: outline filling, working outwards from one central panel, and a kind of sketch-work, using larger blocks of a single colour that are divided by overpainting.

Begin by pencilling in a few straight lines with a ruler. This will give a constant base to your bookshelves. If you feel you need more guidelines, make rough outlines of the tops of the books, but do not pencil in the individual books.

Start with the most conventional method. Using the small brush, outline individual blocks of colour very carefully, and immediately fill in the central panel. When you paint adjacent 'books', leave a little white space to make sure the colour doesn't bleed. Fill in the gaps later.

For the fastest technique of all, brush in larger blocks of light colour; when the paint is really dry, subdivide the block with overpainted lines. This same system, by the way, can be used for buildings (see Project 22), for clumps of tree trunks or any other similarly clustered shapes.

Another method is to begin in the middle of the panel with one thick stroke, then work around the edge until the block is filled. You can easily adjust the size and shape by pushing the outline to one side or the other.

When you work on the actual painting, keep in mind contrasting colours; use at least one bright oblong for a focal point, and remember that it's the different-sized blocks that make such an attractive feature of your picture, just as they do in your own bookcase at home.

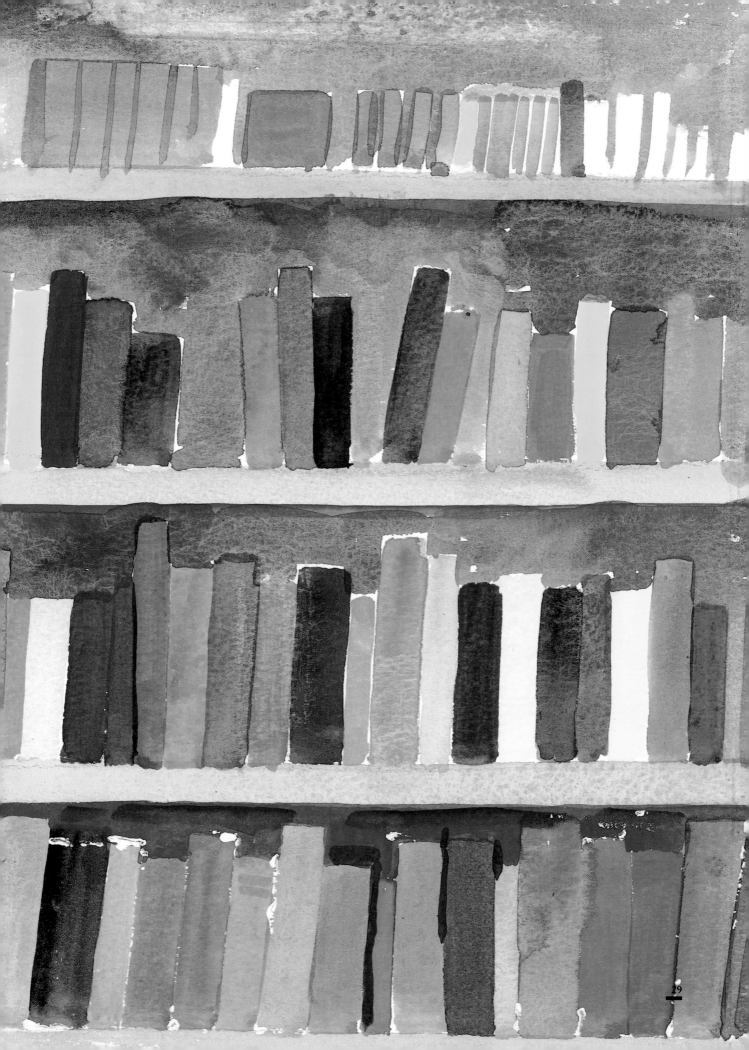

Project 9:

Harebells

Here's another version of apparently random brush marks that are actually placed quite deliberately.

In this case it's control of the thicker brush that is important, together with skill in putting down and picking up the paint with a minimum of blurred edges.

Working with the corner of the thick brush will create a V-shape. The blue paint should be more watery than the yellow used for the wheat field, but not as fluid as the washes in previous paintings.

Think about making a simple, clear shape with one dab. Put down the whole corner of the brush very deliberately, working either in rows or in a pattern.

Make large dabs at the top of the paper, working down to small dabs at the bottom. In general I work from top to bottom and from left to right on the first layer of a painting, so that my hand won't brush across the wet paint and blur the image.

See how close you can get the dabs without making them run together. Where I used more water, the paint left darker lines within each shape. By the time I got to the bottom of the page I was using very little paint, and the shapes became extremely pale.

Turn the paper upside-down and everything falls into place. Add a few light strokes of green, curving up and then down and, as if by magic, harebells appear as they might do growing in a field; the nearest flowers are the largest and the deepest in colour, the ones in the distance are smaller and paler. Natural perspective as well as brush strokes in one easy session!

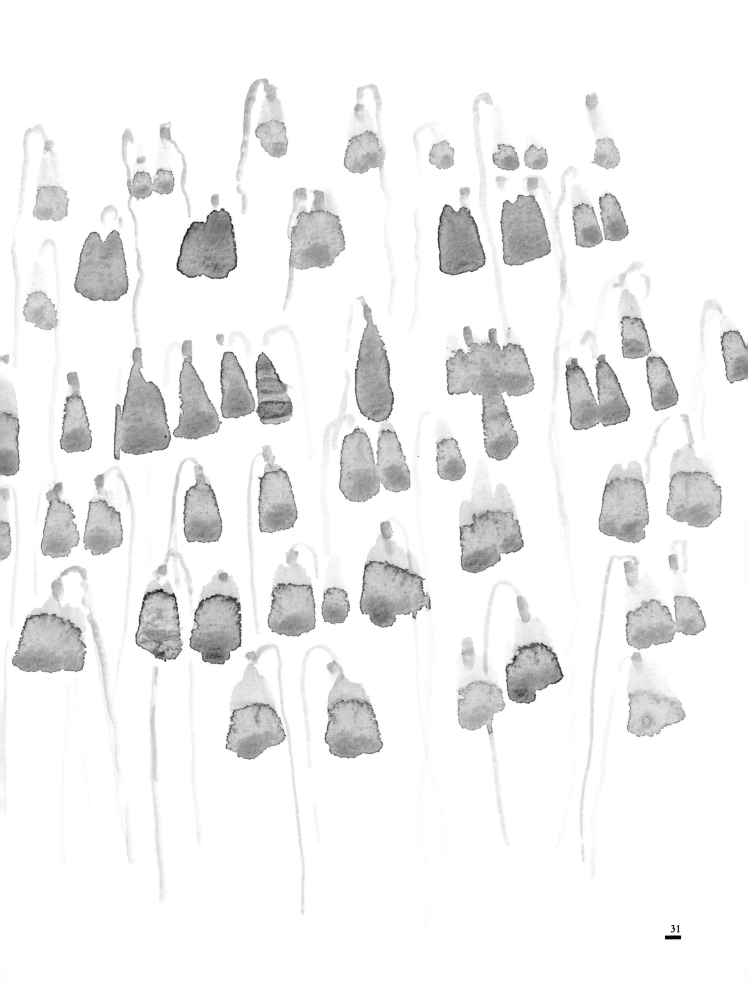

PART FOUR: COLOURS

The primary colours are red, blue and yellow; everything else is a mixture. Blending the three primaries will create the secondary colours of orange, purple and green.

Beyond these simple mixes, there are no limits to your colour sense or imagination. Just remember that, except for particular effects, you should never mix more than three colours. Colours quickly lose clarity and end up as muddy browns and greys.

This is a good primary colour palette to buy when you begin:

Cadmium Yellow Cadmium Red
Ultramarine Blue Ivory Black

Mix your colours on any white surface in order to see the true pigment. Paintboxes usually have white-enamelled lids with moulded cups; if not, use a few old white pottery saucers.

For best results start with good-quality paint; cheap boxes look like wonderful value, but the pigment is often so diluted with clay that very little colour is transferred to your brush.

Here are colours to add once you have mastered the primary pigments and their mixes:

Yellow Ochre Raw Sienna
Alizarin Crimson Venetian Red
Burnt Umber Prussian Blue
Viridian Green Cobalt Blue

Teapot & Cups

Watercolour is not always a quiet medium with subtle shades. The three primary colours, in particular, can sing out! This project shows you what can be done with them.

Use tube colours if you have them, with almost no water. Dip your slightly damp brush directly into the pigment, and make swirling circles and shapes to get used to handling the thick paint. Rinse the brush thoroughly between each colour, but get as much water as possible off the fibres before you start again. For these hefty cups and teapot, the large brush is the better tool.

Let the first washes dry completely, then go over one side of your shapes with another wash. You'll see that immediately your flat shapes have roundness and shadow.

A second layer on top of the flat background colour can also create subtle patterns. Don't try to make the design too regular; it detracts from the fresh, spontaneous effect you are aiming for. Stopping the pattern along a top straight line gives you apparent depth without any additional work.

Use very simple objects, such as a teapot and cups, a bottle, a bowl, or children's building blocks. Leave a tiny edge of white around each shape when you fill in the background. Matisse used such simple shapes and primary colours to great effect, so sophisticated subtlety is not everything!

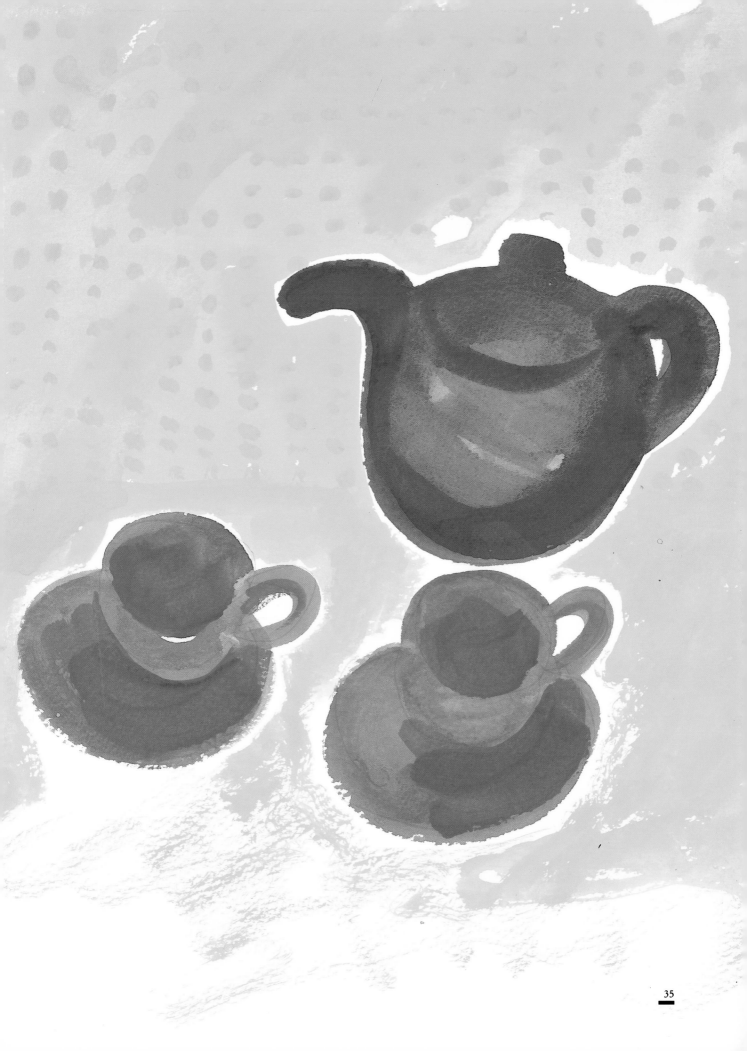

Parrot

Secondary colours are made from combining two primaries. Use the thick brush to start your mixing; you get more of an effect and can see the result more clearly.

Think of an image for which these three colours are appropriate. I found a tropical parrot at the zoo, although it certainly didn't have an orange tail! Art Deco designs on plates and wallpapers often featured these colours. But don't worry too much about being naturalistic – delightful pink elephants and red teddy bears are all grist to the painter's mill.

Whenever you mix colours, always begin with the lightest colour. Add the darker tone, literally drop by drop, until you have exactly the shade you want. Remember, too, that most colours dry on the paper to a lighter tint. For purple, begin with red and add blue; for orange, begin with yellow and add red; for green begin with yellow and add blue.

When you start on the project, first draw the perch in pencil right across the page. This will give the whole design a central axis, making it easy to judge where to put the head, the claws, etc. Trail the brush to create the texture of feathers. Leaving a thin line of white helps to define the picture and add crispness.

Work in sweeps, with a fairly dry mix, so that each colour can be kept separate. Trail the brush at the end of the stroke to give extra texture.

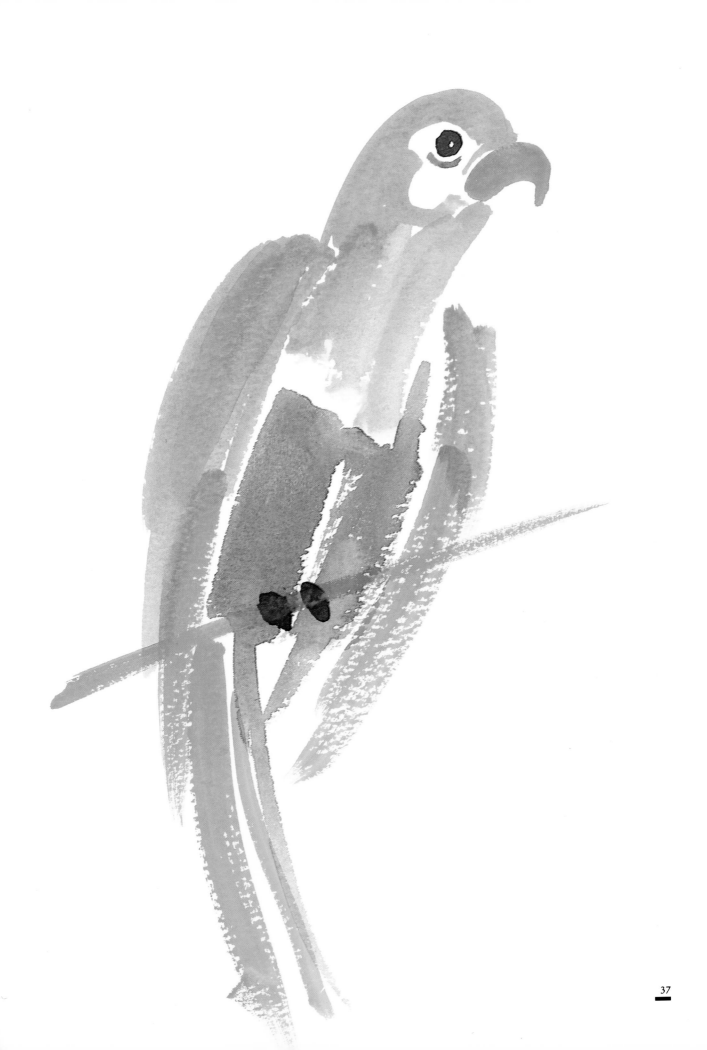

Birch Tree

Once you have tried mixing paints in different quantities, you can create a rainbow of subtle shades. Start with the primary and secondary colours; try them in various amounts, and with more or less water, depending on how light you want your washes to be.

A drop of blue added to yellow with a drop of black makes a subtle leaf green. For other seasons, add a drop of red to make a lovely autumn brown; add water to lighten the tone.

The leaves are simple splashes in varying shades of watery green and yellow.

When you begin the picture, start with a very light blue wash over the paper.

Short, thick sideways strokes, using the large brush, are best for the trunk. Go over the wash with a dry brush and the trail marks will look like birch bark.

Branches are made with the thinner brush, drifting over the paper so that the lines are not too precise or too regular. Leave gaps here and there as if the branches were irregularly covered in leaves.

By now you should have had reasonable experience of handling mixes. So you can save time by buying a larger group of colours. But do make sure you can mix them from the primaries first – then you will have a better feel for the medium and how it works.

Add these colours to your palette if you are confident that you have been handling the primary and secondary colours with ease:

Lemon Yellow Indian Red
Raw Umber Cerulean Blue

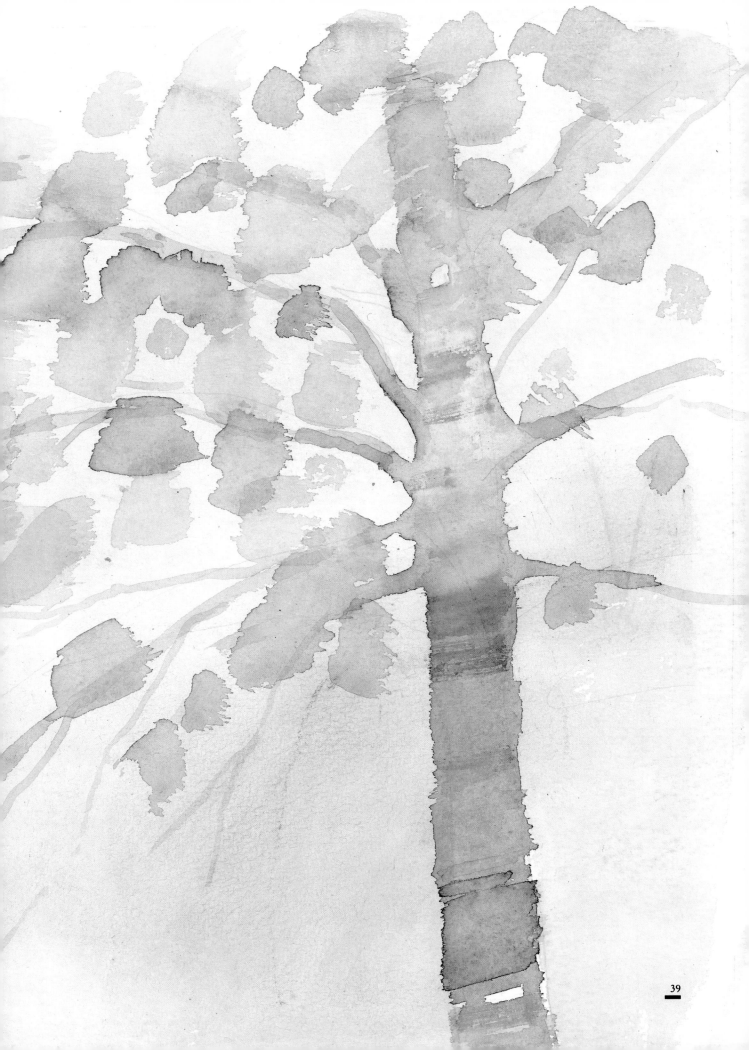

PART FIVE: TONES

After experimenting with wash, colour and brushwork, it's time to look at tonal values and their vital role in watercolour.

Tone means the light, medium and dark shades that are in all colours, as well as in white. Look at any object with your eyes half-closed; the colour fades and you see the contrasting dark and light.

Most pictures have more depth and clarity if they use tone in their composition. When the contrasts are well balanced, you'll see the picture just as well in black and white as you do in colour.

Tone is used for three basic reasons. It gives shape, form and perspective.

Look at the darker edges of the harebells in Project 9: they help to define the *shape* of the flowers.

In Project 10, the darker tones of blues and reds give rotundity. This is using tone to create *form* on a flat surface.

Dark tones tend to push forward and to be seen as foreground, light tones recede towards the horizon. Tone used for creating *distance* is shown in Project 13.

Look at how children draw in flat blocks of colour. Without light and dark variations their paintings have no depth.

Tone is a valuable tool for the artist. Recognize its presence and you'll use it effectively.

Boats on the River

This is probably the simplest expression of tone; dark, medium and light black tones are all there are on the paper, and yet the picture is both clear and full of perspective.

Dark tone is used for the foreground – in nature, things nearest to you tend to have the most colour and substance. Draw three squares and paint one with pure black pigment – it will seem to be nearest to your eye, just as the darkest boat looks as if it is moored closest to the shore.

Medium tone is used for the middle ground, linking the dark and the light. Medium tones seem to give the picture space, occupying the most comfortable portion of our visionary field.

The background is the palest tone, a natural effect of the atmosphere. The further you can see, the paler, more blueish or grey in tone the colours will be.

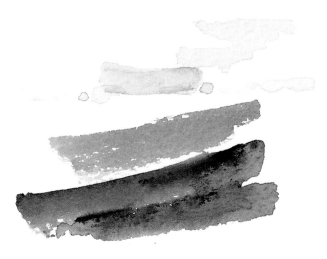

Try making a landscape with just a few strokes of tone, and see how much you can pack into a minimal arrangement of washes and lines.

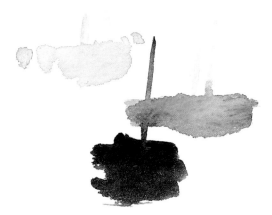

Put the picture together quickly, working in simple masses with a few delicate grey lines for the masts. Boats are a good choice for a tonal painting because your eye and brain accept that they look appropriate in all three places on the river: foreground, middle ground and background. At this stage don't even think about detail. Just get the masses of tone nicely separate.

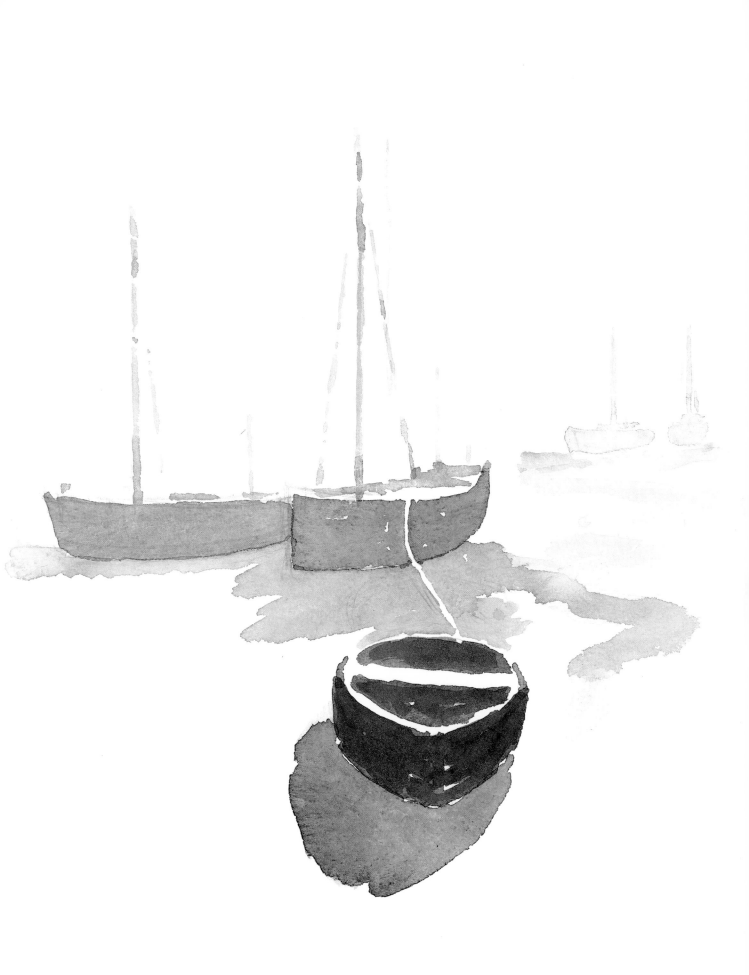

White Jugs

Painting without any colour can be extremely interesting. I chose all-white objects with a white curtain background for a sophisticated tonal study, using many more than three simple gradations.

These are complicated shapes and it's a good idea to begin with some pencil sketches. Trace the shapes of the jugs individually; their handles and spouts are interesting and varied. If you get them right, then the rest somehow falls into place.

With a horizontal subject you do need to think about the shape of your paper. If this book were landscape in shape, I would have painted a wide picture but, as it is upright, then the composition had to change, too, to accommodate the shape.

Mark the highlights between pencil outlines. That way you can choose to leave them white or wash over the picture and then use a little white body colour on top. The first effect will be light, the second heavier and more like an oil painting.

Look at the two ways to show the white embroidery on the white linen background. Above, I used touches of white against a darker grey tone; below, the reverse – touches of dark grey on white. It helps to keep the light above the shelf, and gives added solidity to the base of the picture.

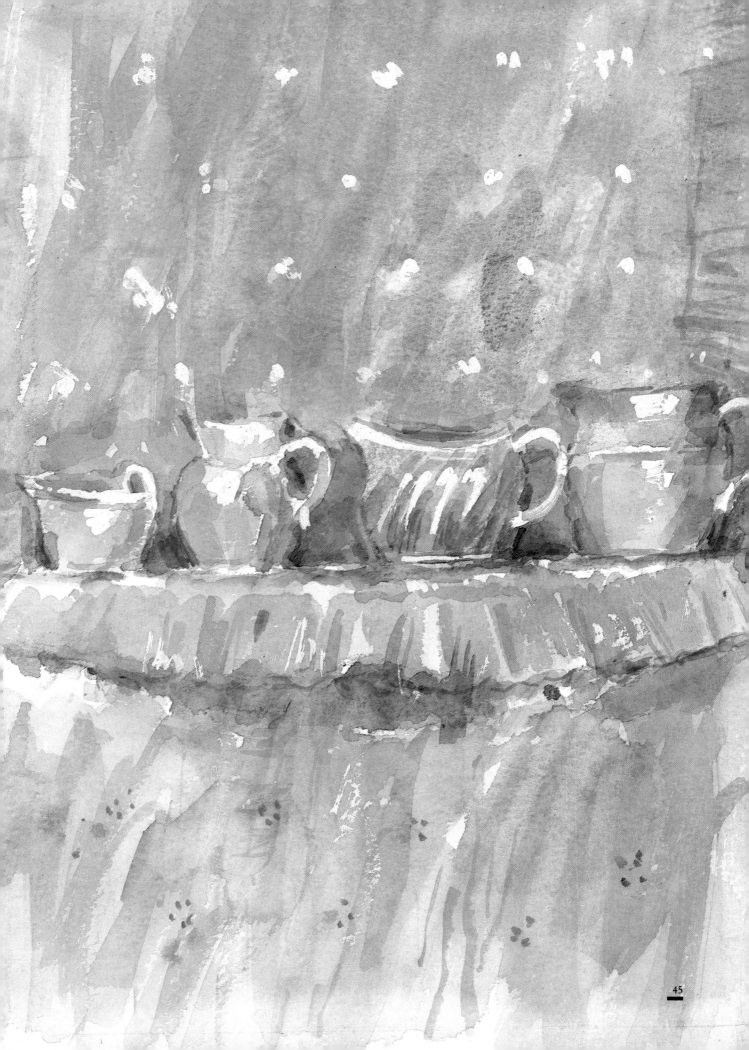

Project 15:

Light & Dark Tones

Town in Greece

Light and dark tones join with colour; pale houses in sunlight are emphasized by the dark trees and the sea, with the paler hills in the distance in the lightest tone of all.

You can use a postcard of a seaside or an inland town, but it should have tiers of houses so that you can experiment with light and dark blocks of colour.

Begin with squares in light and subtle tones of white, cream and pale pink. Start at one edge of the paper and build up and across right to the opposite edge.

When you start the picture, because it is more complex than most of the earlier projects, you might want to sketch in the overall shape. Begin at the top with the blue wash of the sky and the distant hills, move down through the light blocks of houses, the windows and roofs, and then add the sea and the trees at the very end. Window and roof colours grow fainter as the town rises and recedes away from you.

Keep an eye out for the tones of buildings in different parts of the world – light walls are usually found in warm climates, darker walls or brick and grey stone in cool climates.

Detail is going to suffer in any painting done so quickly, but sketching in windows and doors with a swift line of shadows will make a townscape come alive. Using the smaller brush, paint groups of oblongs, then try groups of arches, longer oblongs, etc. These are all in the middle tones, so keep the colours of medium strength.

The dark tones of the blue sea, the green trees and one or two roofs will anchor the whole composition firmly to the foreground.

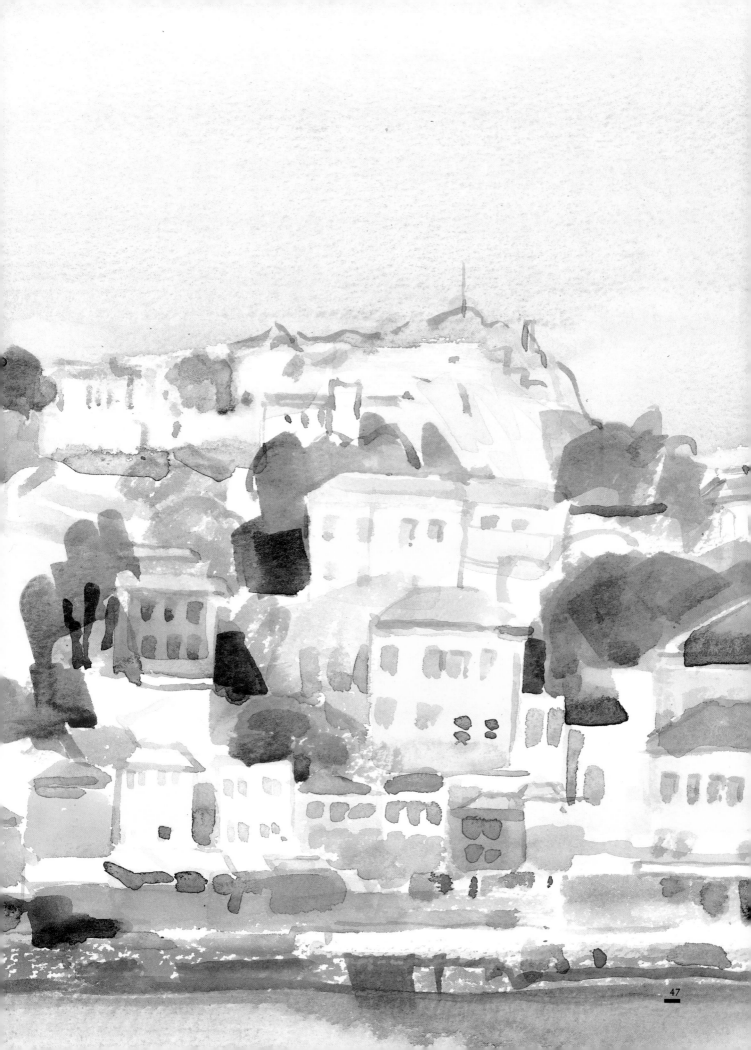

PART SIX: DIFFERENT PAPERS

Classical artists were trained to appreciate the use of tinted papers. Much of their work was done with sienna chalk and black charcoal, on grey or cream paper.

This allowed the texture of the medium to show up clearly without the cover of paint.

I like the Ingres paper popularized by the pastel artists; it gives an attractive ribbed texture.

Part Two showed examples of how to use white paper as a colour. Tinted paper can do the same, acting as a unifying surround as well as the central focus of tone and atmosphere.

There are many other papers that you can use for special effects. Buy at least one or two sheets of rough, handmade paper and see if the surface suits the work you want to do.

Handmade papers come in various weights; 200lb (425gsm) is a good choice, with various finishes (see the Shopping Guide for details). Brush marks will look completely different on different surfaces – rougher papers will catch the individual hairs and create a speckled effect.

Trying out new surfaces for variety and interest is a fascinating project, and one well worth the time.

Project 16:

Teapot & Flowers

Tinted grey paper is used as part of the painting. The subject, a pewter teapot with soft blue and white flowers and very grey leaves, blends perfectly into its background.

The first element is outlining the object without actually painting it in. Start with a very soft 6B pencil. Use it lightly, then you can rub it out easily once you have finished.

Concentrate on the outline and not the details, and don't be afraid to leave out bits if they get in the way (I left out the open teapot lid). Painting is a selective art, and it's far more important to leave things out than to cram everything in.

Practise curved handles and spouts, trying to paint them in one easy stroke. They occur all the time in still life.

Use the edge of your large brush and paint long stems very lightly, then squiggle downwards, circling around the line. Add a few soft blobs of purple and a lighter blue for the flowers. Don't try to draw botanically correct sprays, but splash in leaves and flowerheads with abandon!

When starting, make a few very light pencil strokes to mark the edges of the flowers, to be sure that there is enough room on the paper.

White body colour will add highlights to the pot and the top sprays of flowers.

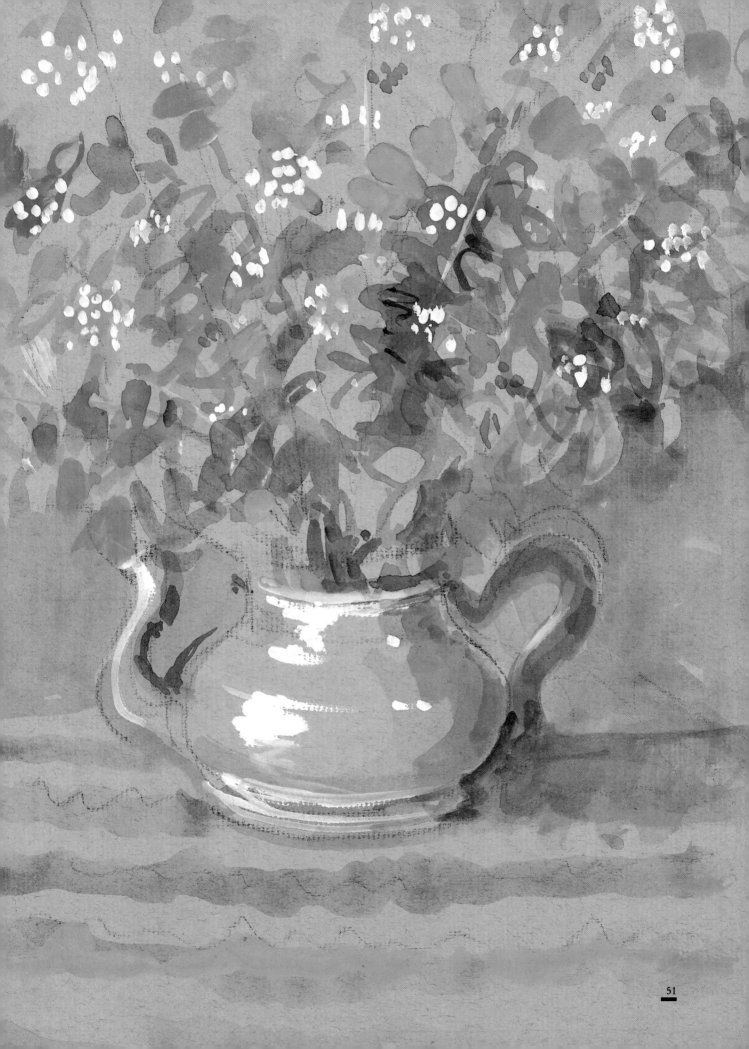

Lacquer Boxes

Watercolour washes tend to be broad and
watery, rather than precise, so it is good
practice to try small detailed patterns and see
what you can make of them. This project is
based on a group of lacquer boxes on a
mahogany tabletop.

Find something similarly small and decorative
– perhaps a few patterned plates or swatches
from your curtain- or wallpaper-hunting days.
With the small brush, practise sketching the
patterns in watercolour. Using dryish paint,
hold the brush high up on the handle, and let it
trail across and sideways to make trellis and
ribbon lines.

Draw a larger shape and grain it with a very
dry brush in a slightly lighter brown. You can
use pale beige on darker beige for light woods,
or black on reddish brown for dark mahoganies
and rosewood. Wobbly Zs and Vs are good
graining patterns. You can even try using the
professional decorator's tool, the tip of a
natural feather.

Start your picture by drawing the outline of
the table, then painting the boxes and only then
graining the tabletop. Paint tends to sink into
Ingres paper, so you may have to go over the
patterns on the boxes three or four times, to get
the colour to sing out.

This is one time to ignore tonal contrast. If
you were to use a pale background it would
diminish the rich effect. There are no rules that
don't have exceptions.

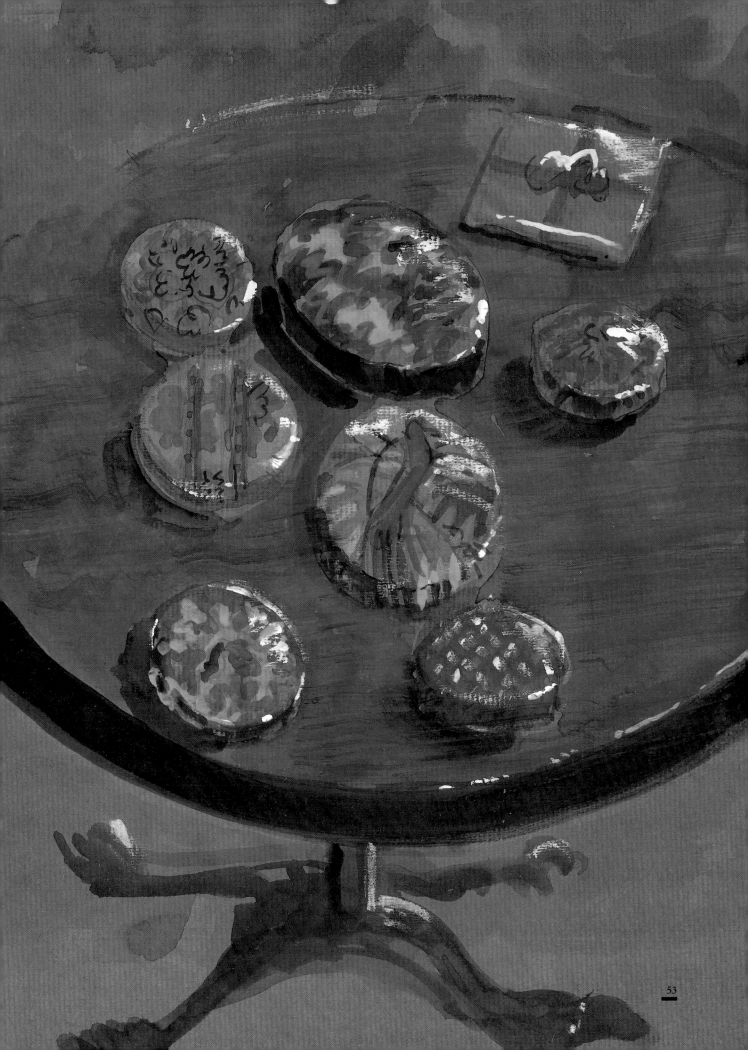

House in a Wood

The choice of paper will give you the impetus to try out new effects. Buy three or four sheets of handmade paper with different surfaces; some will have a pattern impressed upon them, others will be left as they come off the form, with an irregular finish (see Shopping Guide).

The edges of the washes can run together – the colours blend that way and the shapes retain their impressionist feeling.

Mix two or three washes in greens and blues, then work across the top of the paper in thick, easy strokes. Let the brush glide across the surface without stopping; the hairs will skim the highest parts of the paper, and the pattern will be thrown into relief.

Let the water drain from the brush, and then repeat your brush strokes below. You'll get lovely grainy flicks of colour. Try mixing a deep, vibrant pink and wash it across the paper in one stroke. A little extra blue in the mix is perfect for the shadows.

When you start the picture itself, begin with the pink wash on one side, then work around it with blues, greens, yellows, browns. That way the final result will look as it should do – a distant glimpse of the pink house seen through the trees in full leaf.

Do a few similar washes with the same colours, using a smoother paper. You'll see what a difference the various surfaces make. While detailed interiors and still lifes can benefit from a smooth surface, I believe most landscapes work better on a rough texture.

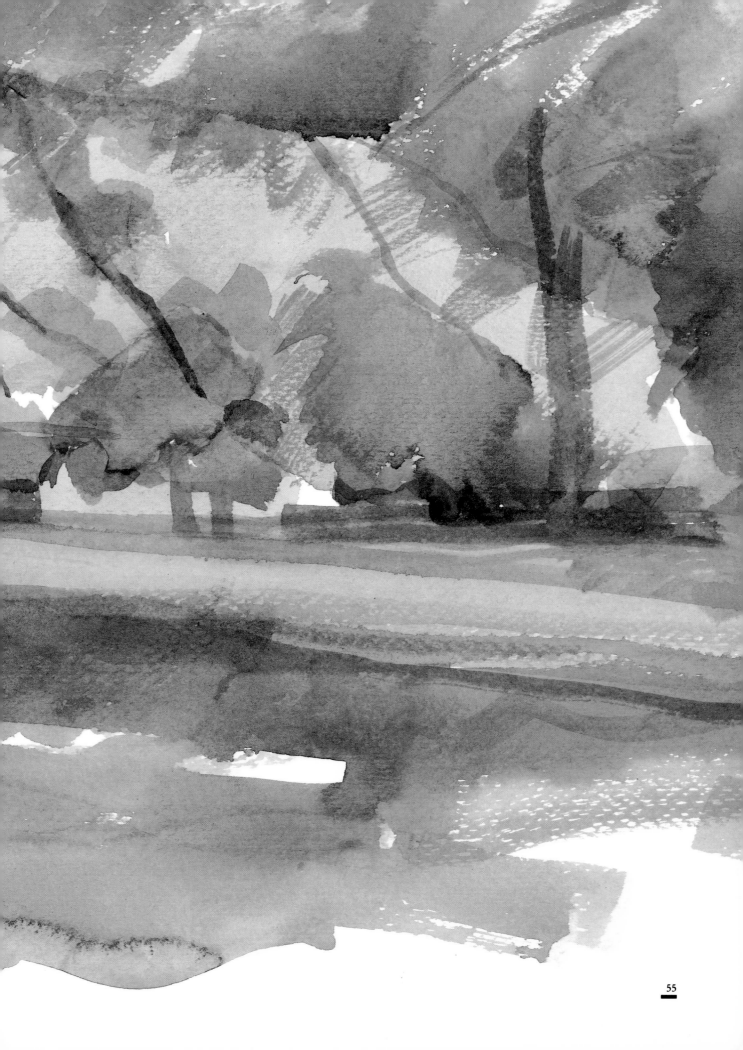

PART SEVEN:
BRUSH TECHNIQUES

Once you have tried out most of the basic brush strokes, home in on some of the other techniques that can make painting more interesting to the artist as well as to the viewer.

Dry-brush technique can be used entirely on its own to give expressive and quite fascinating results. It is especially appropriate for quick sketches, with a wonderful feeling of light and freshness.

To try out spattering you will be using a different tool, an old toothbrush. Spatter looks so different from anything else that you can spot a little patch in all sorts of paintings. It often appears as gravel or the pattern on wild birds' eggs.

The Deck Chair project is unusual because it relies entirely on the toothbrush, except for eight very small brush strokes.

The third technique, wet-on-wet, is simplicity itself to start, but not so easy to stop!

Because paint on a wet paper has a will of its own, even the most experienced artist has to allow for the unexpected. Using wet-on-wet properly demands the most creative imagination of the watercolour painter.

All the techniques can be used together or separately, giving any artist a hundred variations and a thousand skills.

Project 19:

Dry-Brush

Flooded River

The best equipment for dry-brushing is a stiff bristle brush, but you can also use your large brush, or even the toothbrush used in spattering (Project 20). Begin by trying the technique with lots of pigment and as little water as possible. Just dampen the brush enough to get the paint to liquefy.

Try adding just a little more water to the brush when doing a few solid areas like the trees. You will soon get into the rhythm of picking up just enough paint to create the effect you want.

Move your arm in large sweeps. That gives the paint time to fade out gradually so that the end of each stroke is more and more textured with open spaces. Always work from left to right (the opposite for left-handed people), and practise making the strokes go right across the page.

Mix a dark green and a deep, water blue. A flooded meadow will have long darker strips where the water is shallow, and working the two colours in tandem across the page makes a very vivid scene. Clumps of trees and bushes recede into the distance.

Begin painting the scene by putting in the horizontal line of the horizon. A good general principle in landscape painting is to keep the major part of the subject just below the centre of the page. That will give a lovely big sky full of space and light.

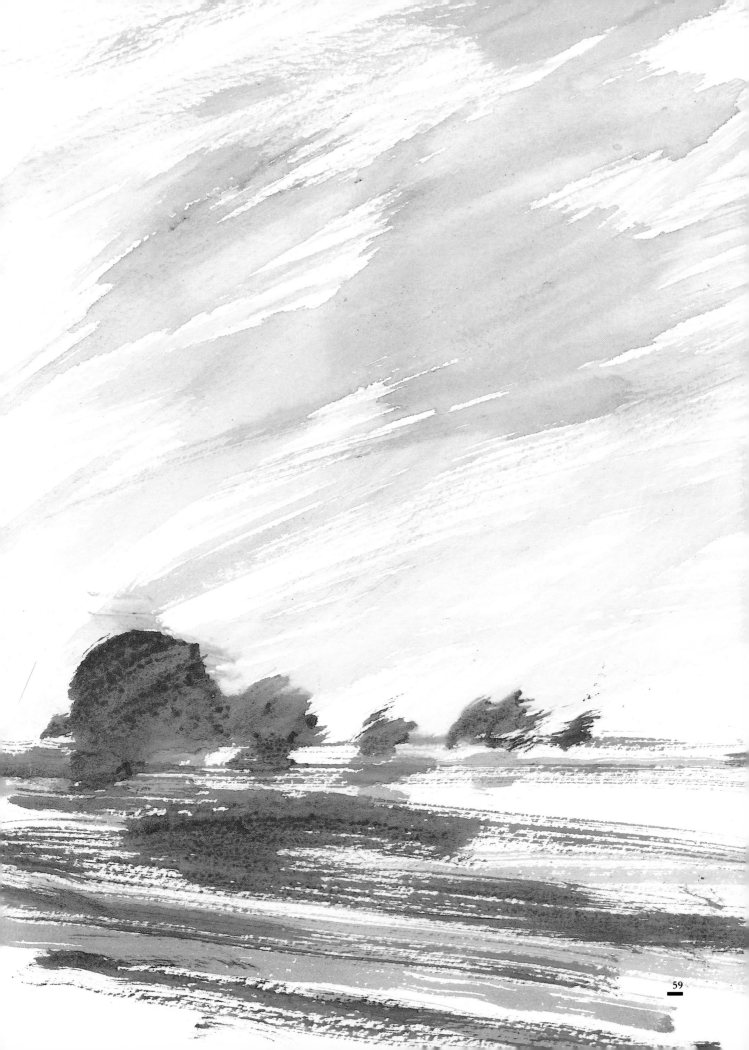

Deck Chair

I do enjoy the fun of spatter patterns. It's like nothing else in painting, and this is the first time I tried it on its own.

You will need a very stiff, old toothbrush and a few sheets of ordinary paper to mask off one area from another. Spatter lives up to its name, so clear your working space – the paint dots get over everything! I work with the paper absolutely flat so that there is no danger of running, to spoil the effect.

Mix some fairly thick paint, dip the toothbrush in along its length and then, holding up a card along the line you want to keep free of the dots, flick your thumb against the bristles. It is much better to go lightly on the paint and spatter twice than to use too much water and find heavy dots everywhere. Practise until you can control both the direction and the amount of the spatter.

The chair is painted with the small brush, used very lightly, but with plenty of dryish paint. Start with the left-hand upright strut, making one long, three short and another long, slightly curved mark. Paint in the seat struts in the same careful way.

When you begin the project, draw the straight lines of all the different spaces first. Stick down paper on either side of the area you want to paint. Spatter, then let the paint dry before you lift off the mask and replace it for the next section.

Work on the sea first, the sand next and then the sky. Add the deck chair only when everything is absolutely bone dry.

Flower Swirl

Nothing else has such power to astonish and surprise: touch a wet paper with a loaded brush and there's a rainbow of shadowed magic, running out into the margins but without substance or hard edges.

The skill in using wet-on-wet lies in the amount of water; start with the paper flat on the table. When, and if, it seems appropriate, you can tilt the paper to let the water run, then lay it flat again until the paint dries.

Make very simple shapes, adding a speck of brown here, a blob of blue there, until you see what happens. Sometimes the paint floods evenly; sometimes, if the brush is too heavy with water or the paper too wet, it races out of control in veins of colour.

Wet the paper with a very clean cloth, or dip the entire sheet in the sink and shake it gently before you lay it down. Start at once with a loaded, watery brush.

Try different degrees of dampness with various mixtures of pigment. You must work quickly, but not too quickly or with too much water or everything fades to a muddy puddle. If it looks awful, then wipe away the image immediately with a very damp cloth.

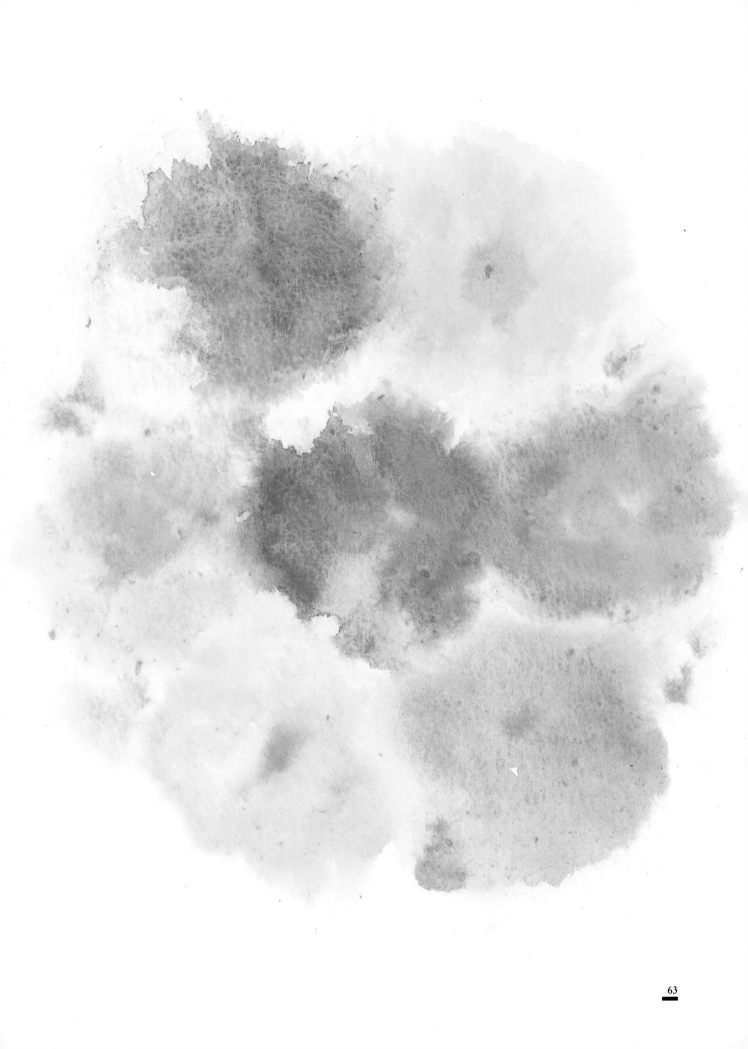

PART EIGHT: OTHER TECHNIQUES

Waxes and resists have been in use for thousands of years. Batik fabrics depend entirely on them, pottery is decorated with them, but for the watercolour painter they are more of a gimmick than a necessity.

However, although the same effect is easily created by painting around an area, there is no doubt that when you are working quickly they really show off their value.

Dry-on-wet is a means of adapting two skills to create a new effect. Learning to control wet-on-wet in the last project will give you the basis for this variation, which can add detail and focus to the mistiest background.

The art of quick sketching is not usually considered a technique, but it's a skill often ignored by beginners. Yet over a lifetime no individual technique will do more for you than the ability to capture a detail, a scene, a face or a pose in a matter of minutes.

Learn what to look for, how to remember, and you'll be on your way towards becoming permanently obsessed, as I am, with carrying notebook and pencil everywhere you go – and what a treasure house of information and pleasure it will bring you.

Street Scene

Liquid-rubber resists can be used at any stage in painting. By covering any space with its impenetrable rubber coat you will be able to wash over the paper without the bother of painting around areas you want to keep clear.

This is particularly useful when there are lots of small spaces where you want to use three or four tinted washes in separate areas. In this street scene, I had just that problem: little windows, textured stonework, a cloudy sky with clear patches.

Try painting the resist over a series of squares. Don't use a good-quality brush; find something small but cheap, and keep it for the resist only. Clean it with water; you'll have to keep rubbing the end to get the dry bits off. Painting its handle with a red band will remind you which brush is which.

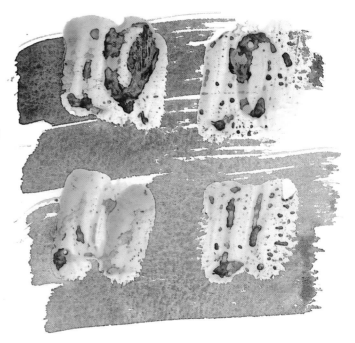

As soon as the resist is touch-dry, slosh over your first wash. Let the paint dry, then test the resist to see if it will roll away when you rub it gently with your fingers. Leave half of the resist spots there, rub the others away and splosh over another wash.

When that dries, gently rub away the remaining resist squares. Half the original blocks will be clear white, and half will have a lighter wash – just the thing for a house with shadows on one side, or for the effect of peeling paint.

Sketch a street scene, keeping the outlines simple. Three or four layers of wash over different bands of resist will give you a fascinating blend of colours and patches. Finish by painting the windows and glass reflections.

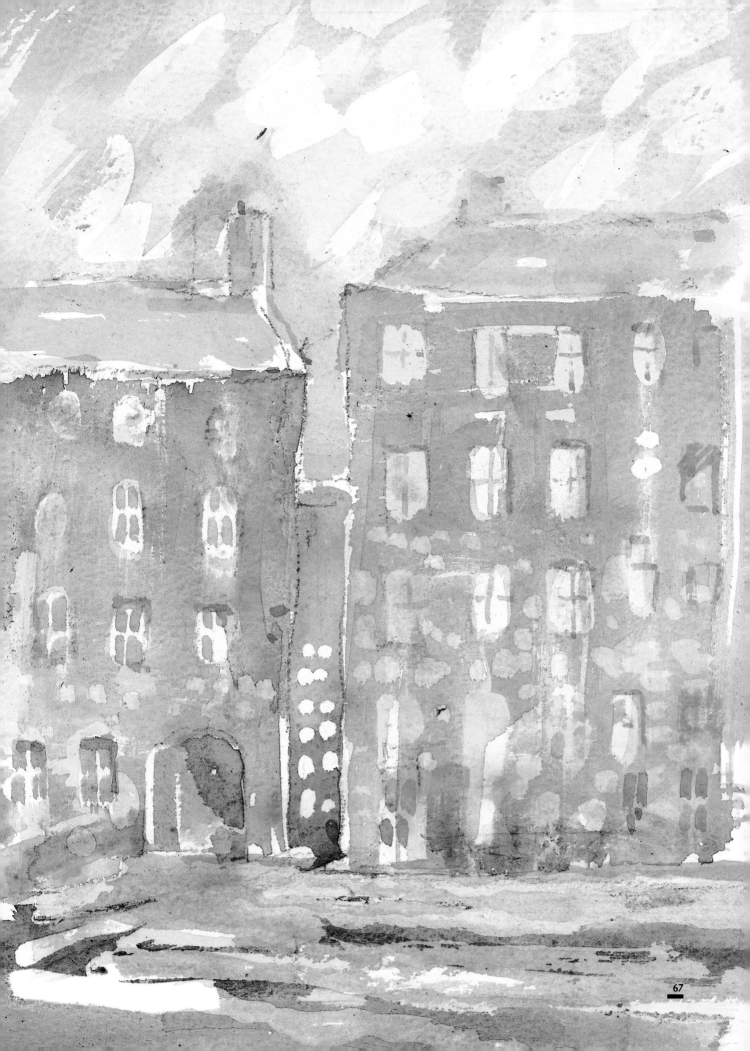

The loose and lovely patterns of a wet-on-wet painting can lead to images and ideas very different from your original plan. Such new opportunities can be realized quickly, with a few touches on top of the paper after it has dried. This technique is called dry-on-wet painting.

Practise flooding three or four pieces of paper with water, then washing over them in different colours. Keep the washes uneven, and tilt the paper a little, moving it from side to side to collect extra colour in pools. You should achieve a kind of moiré pattern.

While the surface is still very damp, add another colour in three or four places. Let everything dry. It will take ten minutes on a hot, sunny day outdoors, but at least an hour indoors in the winter. The paper must be absolutely dry before you go on.

I saw a plate of golden apples on a green cloth; the magic of dry-on-wet is that you can imagine a basket of flowers or the bough of a flowering tree. Pick up a little colour on your brush, not too much water, and clarify the image with a few light strokes: the rim of the bowl, a circle or two around the fruit, a stem.

Experiment with colours and brush strokes but, above all, let your mind and your imagination work freely. As you become more experienced you will be able to be more deliberate, and plan the results before you begin. But always remember to be flexible – if it doesn't look like apples, it might turn out to be a much better painting of plums!

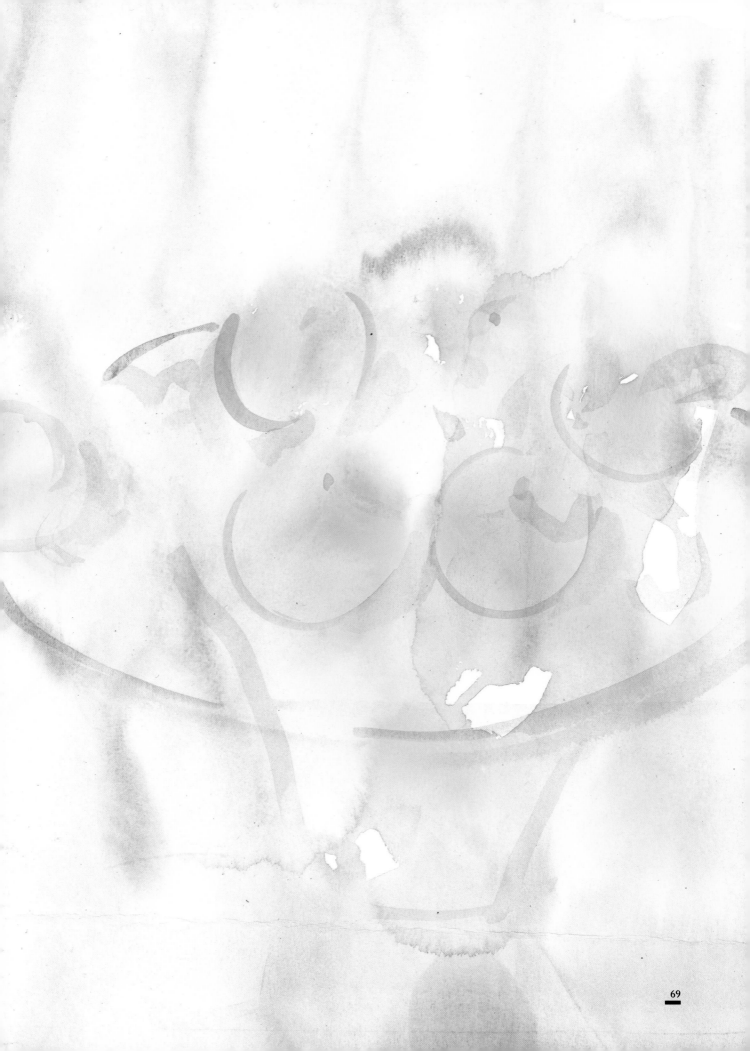

Project 24: Sketches

People

Formal drawing classes are good experience for any artist, but a very surprising number of well-trained draughtsmen cannot sketch. But the rawest of beginners can learn.

There are various tools you can use; measuring will give you proportion and relationship between masses, and it's set out clearly in the Glossary. If you have a camera, photographs are another aid to memory, but will often be blurry. So, to develop an eye for quick observation, sketching people is particularly rewarding. In addition to training your visual memory, live figures are of great value in composition, adding human interest and scale.

Sit down where there are lots of passers-by; a beach, a café, a train station or a shopping centre are all fruitful places. Take with you a medium-sized brush and a little bottle of mixed wash. I suggest wash, instead of a pencil, because it isn't too precise – one brush stroke gives a nice person-shape, and the tip can add feet, a bit of flying hair, an outstretched arm.

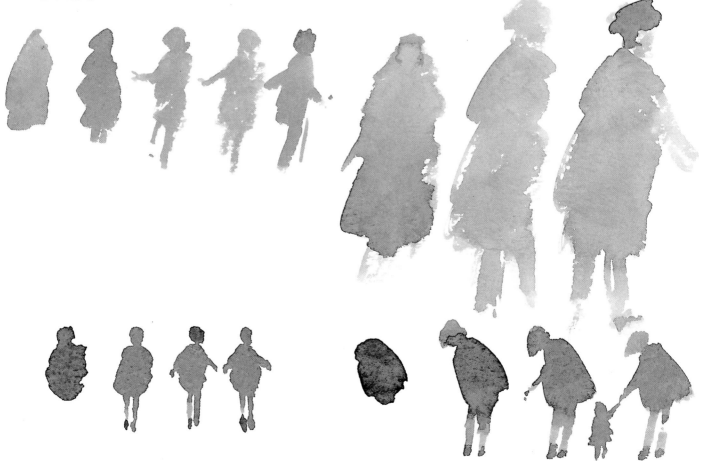

Look for a swift impression, not a portrait! Keep everything quick and light. As you practise, you'll get faster and faster. Don't try to re-work mistakes, just start again. Keep all your sketchbooks to use at home.

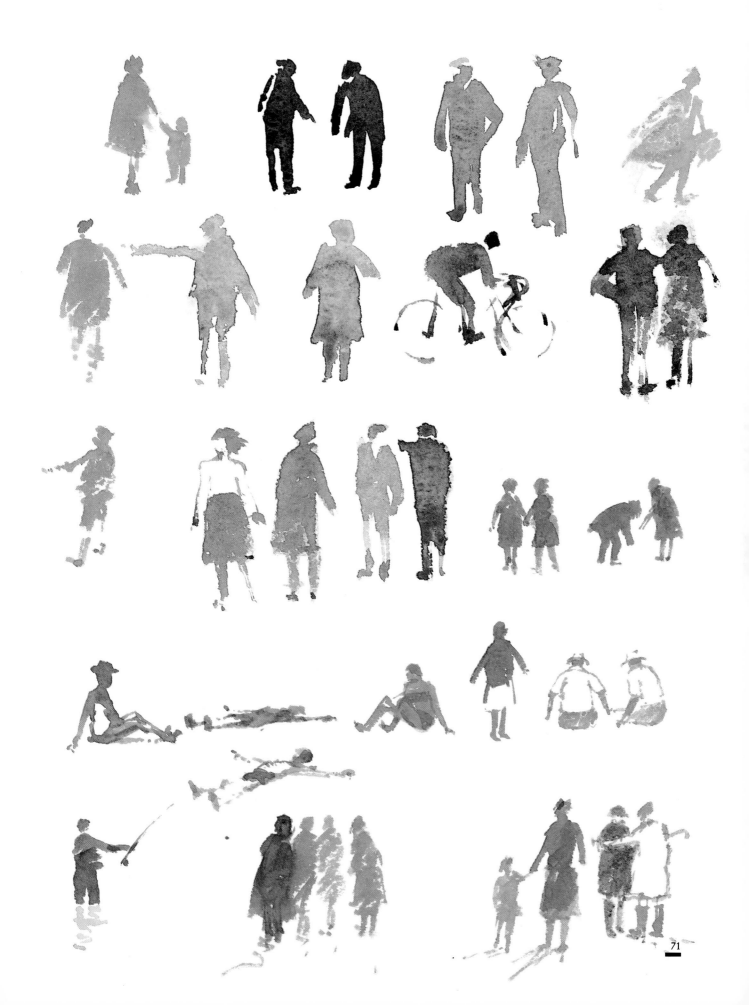

PART NINE: LAYERING

Layers of thin paint used to be called glazing; nowadays, the word is generally used in connection with classical watercolour painting, exemplified by the work of Dürer, Turner, and the Norwich School of Cotman, Paxton, etc.

Glazing is still a tool of oil painters, who use shellac and varnish to cover and protect colouring.

For modern watercolourists, layering is a more descriptive word; it encapsulates the very essence of the medium – multiple layers of transparent wash, used for depth and subtlety of colour.

Each layered wash, allowed to dry completely before the next is laid on top, contributes a shadow of its colour to the whole, which gradually builds up.

The thin layers can also be interleaved with crisp outlines to create the fascinating effect of seeing through water.

The following projects begin with a very simple layering of three colours, then go on to show the tricks you can play with distance and depth.

The final project is an unusually domestic example of multiple layers, in tones of one colour.

Plums

In spite of the subtle differences in the colour, this is a study of just three layers. The essence of the layering technique is to allow the paint and paper to dry completely between each wash. If this is not done, the top wash will start running into the wash below, the colours will begin to blend and although the result may not seem very far removed from your original intention, the actual paint will not be in distinct layers but in a graduated wash. And it will not look the same.

Prove this to yourself by sketching in a plum shape very lightly, then another beside it. Wash over both shapes with a pale plum colour, mixed from red with a very little blue.

Make a new mix of a darker shade and paint it quickly on the first plum to let it spread, wet-on-wet. Mix another brownier purple and stroke a shadow on the first plum while it is still damp. Let everything dry thoroughly. It may take two or three hours or, on a damp day, even longer. Be patient!

After everything is dry, layer a wash over the second fruit. When this is absolutely dry, mix a browny plum wash and stroke a shadow on this plum. Compare your two fruit, and you'll see the subtle difference. Now put together a plate of plums, using the three-layered washes.

If you want an example to pin up for study, copy the entire painting in a wet-on-wet version and pin it up beside the other.

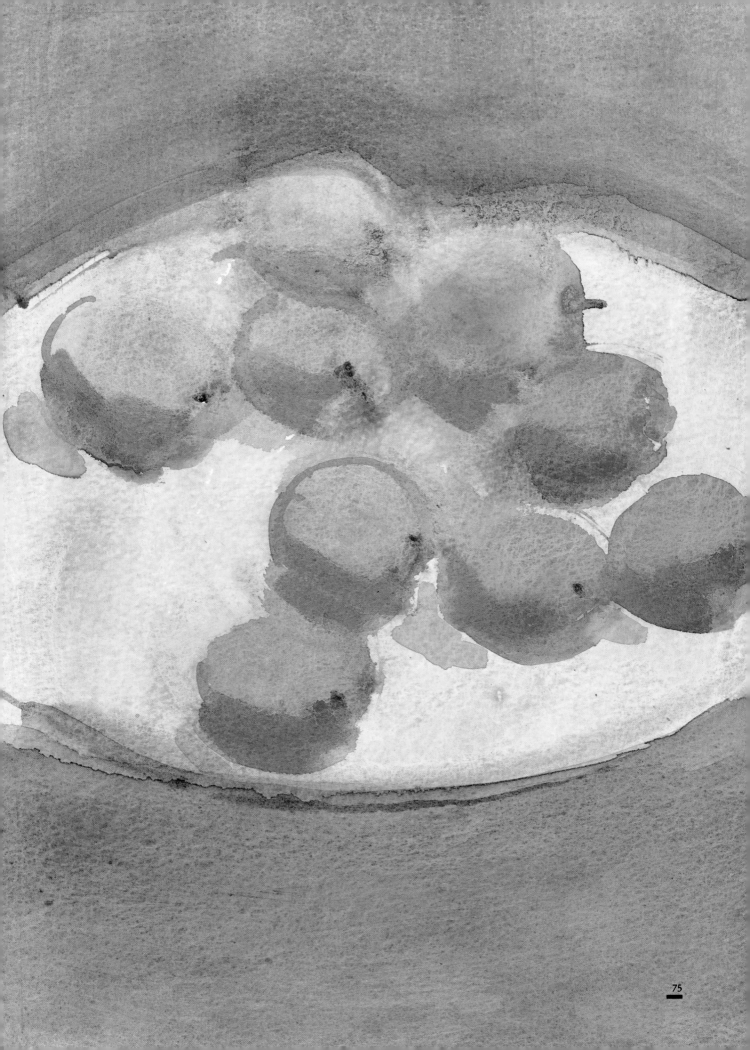

Fishbowl

This is a lesson in making layers work to create a sense of depth. Mix a first wash of light blue, and paint it over a rough circle. Let it dry.

Mix another, slightly greenier wash and paint it over the same area, leaving the first wash showing around the edges.

Practise painting stones and a few waving fronds of sharp green for the weed. Keep your wrist supple and let the weed trail. You can try your hand at an underwater arch, a grotto or a fan of coral as well.

Finally, put the picture together in this order: first, the bowl (draw around a plate if you don't trust your freehand!). Draw in two fishy shapes, anywhere you like. Paint the fish in a bright red-orange. Wash the entire round area with blue, covering both fish. Let it dry completely.

Mix the blue-green wash, and paint it over the blue, leaving one fish out and leaving a hollow curve at the top. If you find it constricts your brush stroke to paint around the tiny fish, then paint one fish with resist first, washing the second colour over everything. Let it dry completely. If you've used the resist, rub it off gently. Paint in the weed, rocks, grotto or whatever you like.

Mix a light blue, paler than the previous wash, and paint it over the same area as before, but covering both fish and all the weed, etc. A circle of grey defines the open mouth of the bowl. The effect created should be of one fish nearer the side of the bowl than the other.

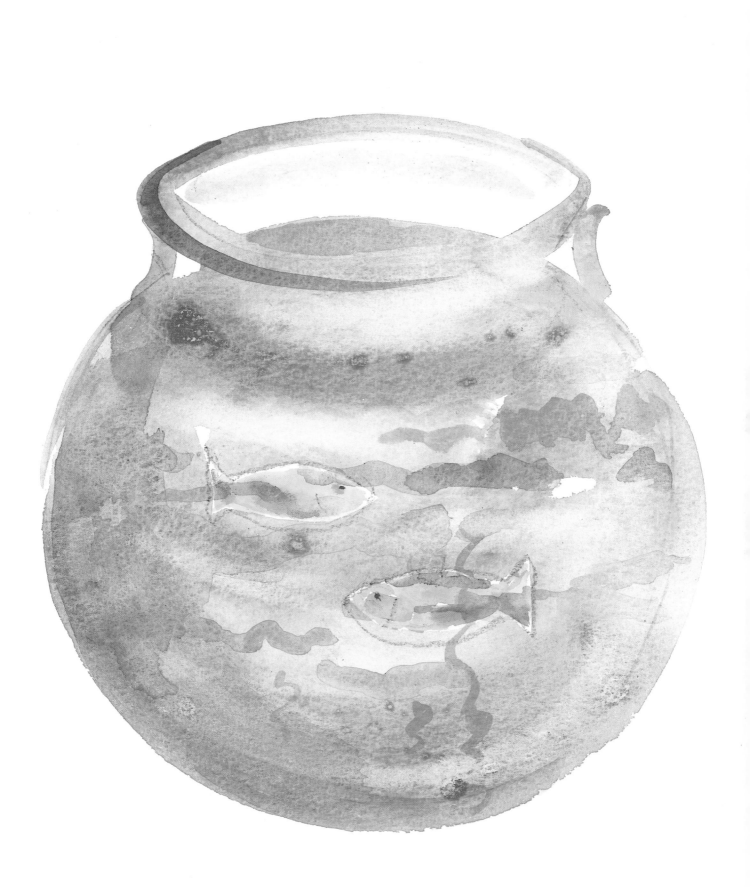

Project 27:

Garden Washday

A view over the garden is usually a pleasant subject but, at the end of a dry summer, mine was full of tired, dusty greens. So I was quite pleased on washday when I had the chance to add extra colour and light, blowy shapes to the composition!

The layered washes are all shades of green. Practise with the lightest possible green wash. Let it dry.

Mix a light greeny-yellow and paint it in bands across the first wash. Let it dry again. As the layers build up, the yellow will reflect sunshine on parts of the garden.

Add varying layers of green for the leaves, getting darker all the time. Use a blue-green, deeper yellow-green, and so on. Paint them on individually, with different-sized brush strokes to give the effect of leaves; let the paper dry completely in between each layer.

Use darker green to add depth and line, dabbing in rounded leaves, outlining clumps and bushes. A small brush for the final strokes will indicate spiky leaves and stems.

Put your scene together in the same order, working from the lightest possible layer to the darkest areas. It's a good idea to draw light outlines of the pole and the clothes, so that you can leave a white space where the sun catches the brightest areas.

Don't try to make the shadows of the clothes on the lawn too accurate – they work best when they are only suggestions.

Add one final stroke of brilliant yellow to make the scene sparkle. Most paintings need a touch of contrast to act as a focal point.

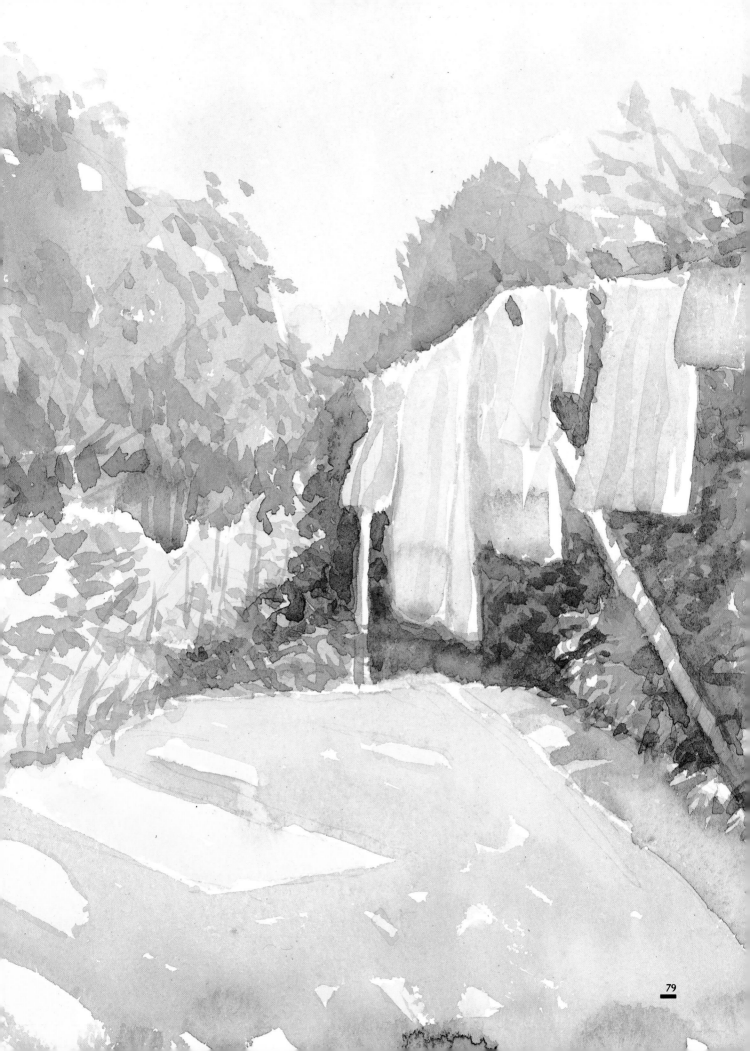

PART TEN:
PUTTING IT TOGETHER

Now you have all the basic information you need to flourish on your own. If you have worked through the projects in this book, you'll have a vocabulary of techniques and skills that should stand you in good stead, no matter where you are or what style you develop for yourself.

Take whatever you can from the examples I've given, then adapt and change them to suit your own ideas. From these thirty paintings you could develop over a hundred or more ideas that give you the spark of inspiration.

Regardless of your level of experience, try out everything. Give yourself a chance to look at new ways of working, and new worlds to discover.

Paint outdoors as much as you can, simply because there are so many fresh pictures and surprising discoveries outside, but paint indoors too, using all the benefits of having plenty of paper to hand, lots of water, and a comfortable chair in a warm room.

When you have time, think a little about what you want to achieve, and where you are going. Painting exists for many of us on different levels, and every one is valuable.

Above all, and beyond anything I can teach you, start painting in order to enjoy yourself, to find a delight that will never fail you, to create a world of your own, with a pad of paper, two brushes and a box of paints!

Lobster Dinner

Even though you may be just starting in watercolour, there is no reason to be frightened of tackling unusual subjects. Although a lobster is an incredibly complex shape, you can reduce it to simple elements of skinny legs, fat rounded claws, and a sturdy oval body. Everything else is an added extra – including the expense of buying your model!

Alternatively, a great deal of fine food photography is published nowadays in newspapers and magazines. Look for clear photographs that show the subject well, rather than incredibly artistic shots with complicated lighting and intricate props.

Begin your sketches with a soft red oval, painted with a mix of red and yellow. Let it dry. Make random texture patterns on top, using blobs of dark colour, dry-brush washes down the centre, leaving flicks of white paper, and so on.

Mixing the shadow colour underneath the lobster is tricky; the red lobster creates blue-purple reflections on the pale blue plate. If the plate were yellow or green, the colour of the shadows would be quite different.

And, if you are lucky enough to be working from a real cooked lobster, then your reward afterwards will be a delicious dinner!

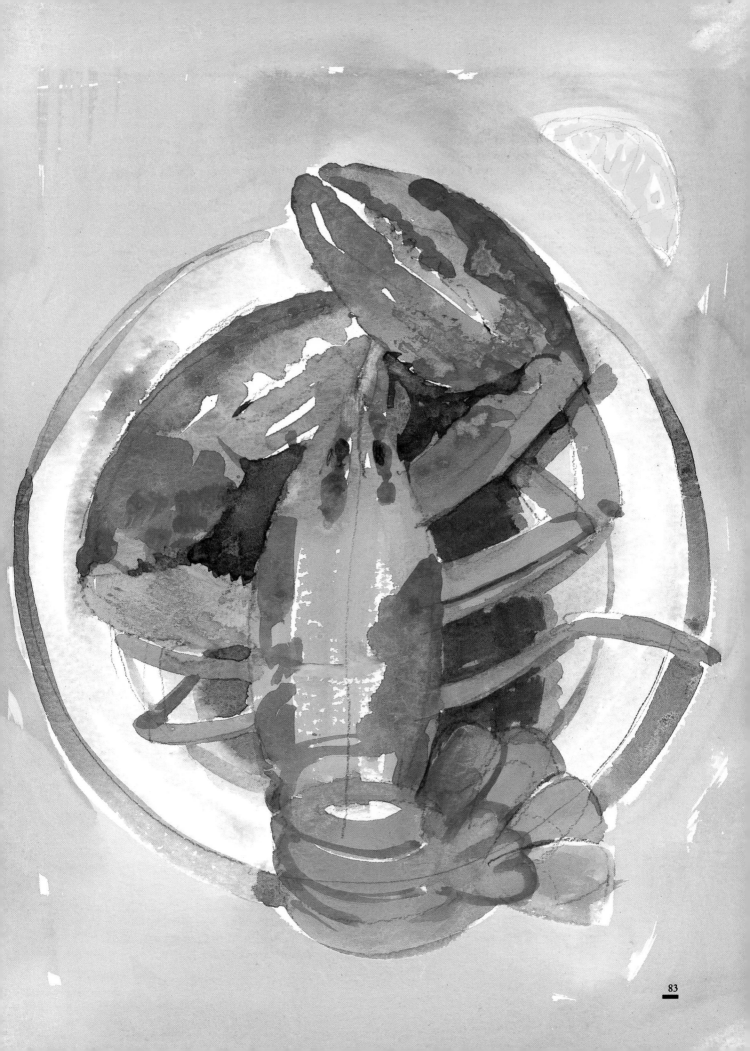

Project 29:

Beach Cliffs

I chose this subject because it combines so many of the techniques we have already discussed. It is typical of the kind of painting you could do on holiday, anywhere in the world. The components are quite simple: a stretch of sandy beach, white paper showing through, striated cliffs, and lazy figures for a relaxed atmosphere.

Begin by sketching; it will get you used to pulling out your pad and paper in the open. One of the awful moments in the life of any painter – amateur or professional – is when the passer-by says brightly, 'Oh, you're painting! Can I watch?' It takes a lot of courage to say you'd rather they went swimming a long way away! Keep the figures light (Project 24) and don't worry if they are a bit stick-like. They will look very appropriate in the finished painting.

Make a few wide washes for the cliffs with the large brush, then tilt the paper back and forward to get a darker wash top and bottom (Project 6). Let it dry.

When the first wash is dry, trail over it with a dry brush in deeper ochre. Use heavy and light pressure to give you narrow or thick lines. Remember that, as the cliffs recede from you, the lines grow lighter and closer to each other until they disappear.

Put it all together by centring your final sketch around the white space of the deckchair. Work from there back to the cliffs and sideways to the sea. Add the figures last of all, when the washes are completely dry.

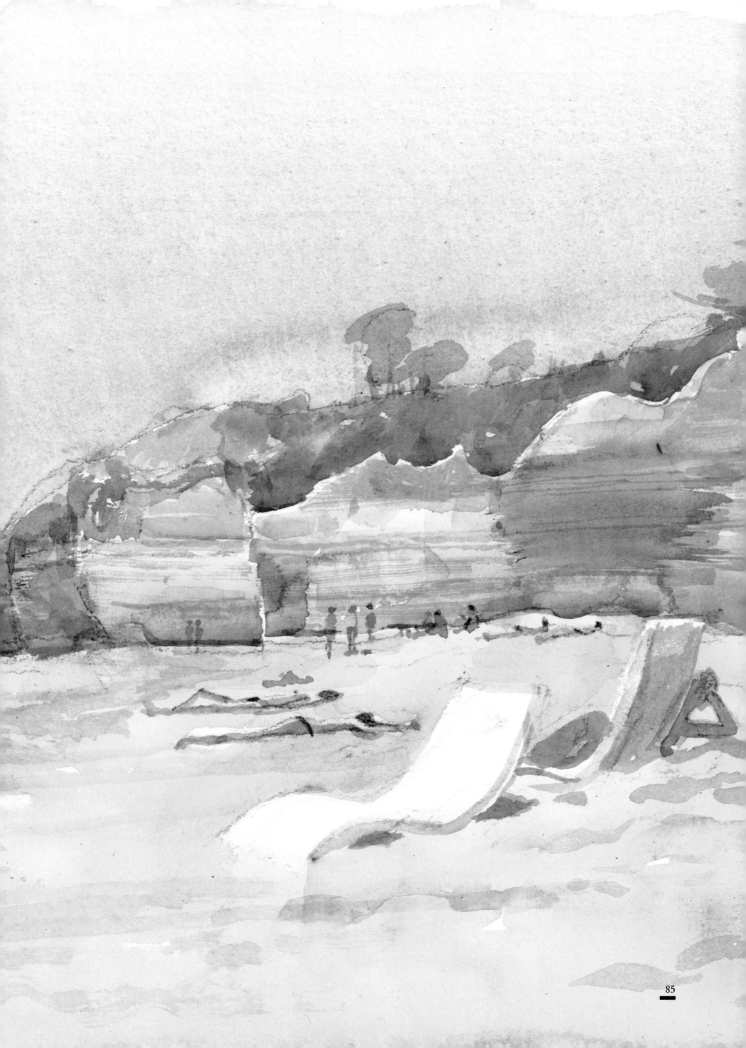

Marina

I've been holding this project for the very last because, like many watercolour painters, I love painting ships, harbours and boats. And they all combine most beautifully in a marina! I settled down on one of the jetties because, at that low level, the clumsy buildings that had showed all too vividly above the row of boats faded into a pleasant, chunky shadow.

Boat shapes are quite simple and, happily, they are all very similar, so, once you have mastered a group like this, you can probably draw a whole boatyard any time you choose.

Use a hard pencil to sketch the outlines. Separate hulls from cabins with a line, then outline the rudders and the cabin doors.

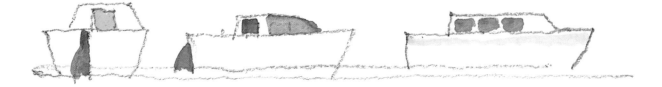

Add the coloured doors, and outline the windows with a darker blue. Each hull has a little darker ripple at its base.

With the small brush, paint in the shadows of the sides of the boats and the rudders, dark against light. Leave the rest white.

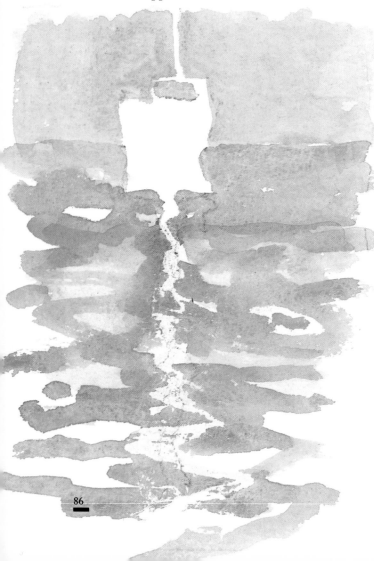

Using resist (Project 22), paint lines for the masts. Repeat, with resist, the shapes of the hulls and the lines of the masts in the water, in zigzags, to create rippling reflections.

For the water, stroke a series of blue and green wavy lines across the resist. Use the small brush – the water needs to look lively rather than solid. Remember to work in wider swirls, the closer the waves get to you.

When you put it together, keep the boats at the top to give the water pride of place. Add a few shadows of the buildings on the shore, and the final touch of a brilliant yellow door. Rub away the resist only when the painting is completely dry.

Index

Note: many of these terms are used throughout the book, but the page numbers given below indicate the most important references, together with the titles of the various studies in italics.